PAINTING
CHILDRENS
PORTRAITS
IN PASTEL

by Wende Caporale

A LEADING PROFESSIONAL
REVEALS HER SECRETS SO YOU CAN
PAINT THE SUBJECTS YOU LOVE
AND EVEN TURN PORTRAITS INTO
A PAYING CAREER

international
artist

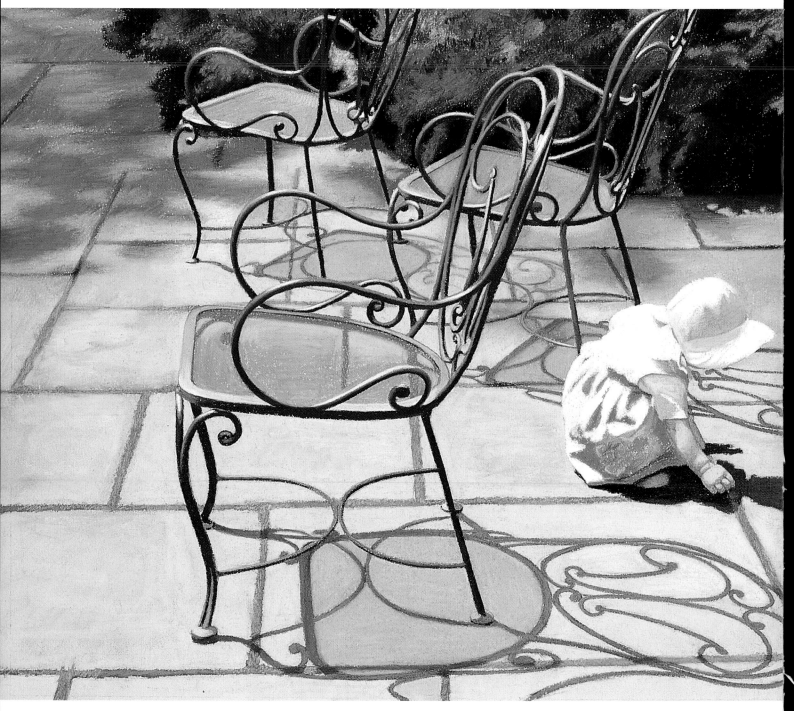

"AVIGNON IN THE PARK", 21 x 29" (54 x 74cm)

PAINTING CHILDRENS PORTRAITS IN PASTEL

by Wende Caporale

For Marcy—
With best wishes for continued
inspiration
Wende Caporale '07

A LEADING PROFESSIONAL
REVEALS HER SECRETS SO YOU CAN
PAINT THE SUBJECTS YOU LOVE
AND EVEN TURN PORTRAITS INTO
A PAYING CAREER

international
artist

Published by:

International Artist Publishing, Inc
2775 Old Highway 40
P.O. Box 1450
Verdi, Nevada 89439
www.international-artist.com

© Wende Caporale/International Artist
Publishing, Inc

Edited by Jennifer King
Managing Editor Terri Dodd
Designed by Vincent Miller
Typeset by Cara Miller and Ilse Holloway

Library of Congress Cataloging-in-
Publication Data

Caporale, Wende
 Painting childrens portraits in pastel / by
Wende Caporale
 p. cm.
 ISBN 1-929834-13-6
 1. Pastel drawing—Techniques. 2. Portrait
drawing—Technique. 3. Children in art. I. Title.

 NC880.C33 2001
 741.2'35—dc21

 2001024295

Printed in Hong Kong
First printed in hardcover 2001
05 04 03 02 01 5 4 3 2 1

Distributed to the trade and art markets
in North America by:
North Light Books an imprint of
F&W Publications, Inc
1507 Dana Avenue
Cincinnati, OH 45207
(800) 289-0963

Dedication

This book is dedicated
to my husband, Daniel
Greene, my daughters
Avignon and Erika, and
to my parents, Edward
and Vera Caporale.

With Love

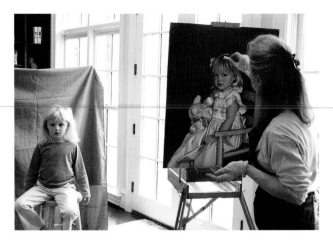

WENDE AT WORK ON THE PORTRAIT OF *"Louise"*

Acknowledgments

First of all, Vincent Miller, my publisher, is the one who put the idea into my head
that I could write a book explaining what I do. My sincere thanks for his wonderful
experience. Jennifer King, my editor, who showed me the reality of extracting these
thoughts and actually getting them onto the page. Her knowledge and sensibility
were enormously helpful in the formulation of the idea.

My husband, Daniel Greene, continues to be my mentor and greatest supporter.
I have learned so much about art as an entire lifestyle. My debt of gratitude would
be trivialized by trying to find the words to express my thanks. Our daughter,
Avignon, who has posed for me numerous times for images used in this book,
has been enormously patient with her Mom and extremely helpful. She helps to
entertain my clients and even took the photos on page 15. To Erika, whose support
and enthusiasm were constant and whose presence adds joy to our life. Special
thanks to my parents, Ed and Vera Caporale, whose limitless generosity, love and
support has encouraged me to pursue my passion.

There would not be a book to write if it were not for the many clients who have
had faith in my abilities. I am indebted to all of them and thank them for their
kindness.

My photographer and friend, Jim Herity, took all the photos of my completed
portraits and has worked with me and my clients on numerous occasions. I owe
him thanks for his professionalism and his artistic sensibility. To my dear friend,
June, who provided a number of the candid photos of our painting outings
together. My thanks to her for her love and support. I also want to thank the
students at the Northern Westchester Center for the Arts, whose support and
encouragement has been substantial. They have helped me more than they realize
by wanting to understand the mechanics of painting and this in turn has required
me to articulate my visual ideas in a comprehensible way.

And, finally, to the artists who purchase this book. I wish you many pleasurable
days of painting, and I sincerely hope that in the pages of this book you will glean
something that helps you further develop your skills as an artist. My thanks to you
for allowing me to share my experiences with you.

Foreword

I am very pleased to be able to write a foreword about the outstanding work of Wende Caporale. Over the last 20 years I have had the pleasure of watching her artistic development, from being a renowned illustrator to her current mastery of portraiture. It has been gratifying to share experiences involving art with Wende and to see her evolve her own brilliant technique.

After reading her notes of preparation for this book, and seeing the skill and care that went into her demonstrations and information, I am sure that any portrait artist will benefit from her methods. No pastel artist should be without this book. Enjoy!

Daniel E Greene
North Salem

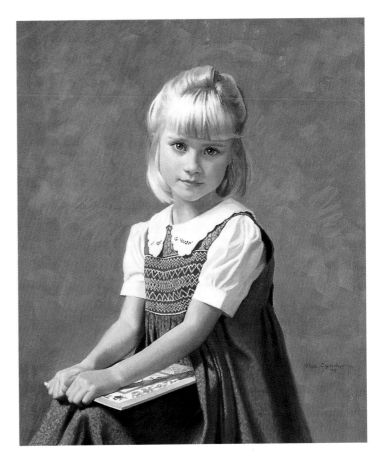

"MARGARET", 26 x 22" (66 x 56CM)

Introduction

Painting portraits of children in pastel is a pursuit I find deeply rewarding, and I want you to enjoy the experience too. My sincerest hope is that you will find inspiration and information in these pages. I have broken the book down into three sections, so you can easily turn to the information you need right when you need it.

In the first section, I have devoted three chapters to explaining how I prepare to paint a child's portrait. In great detail, I show you how to gather information for your first sitting, how to light and photograph the child and how to set up your studio and pastel materials so that you feel ready and motivated to paint.

The second section of this book features page after page of demonstrations, each revealing my working methods for painting portraits of children in pastel. This section is brimming with my advice on composition, lighting options, color schemes, drawing accuracy and so much more. By studying the pictures and captions, you will see how I construct a portrait from start to finish.

And, finally, if you have reached the stage where you yearn to paint portraits of children for a living, Section III is for you. This is your guide for turning your love for this subject into a professional outlet.

Contents

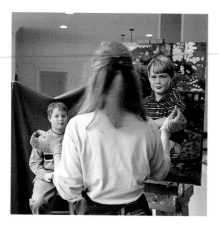

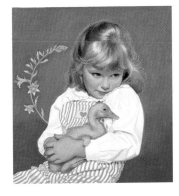
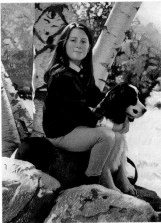
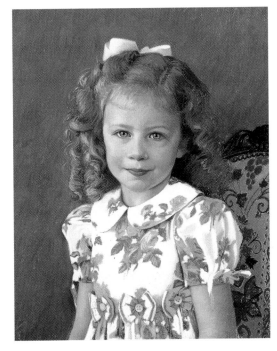

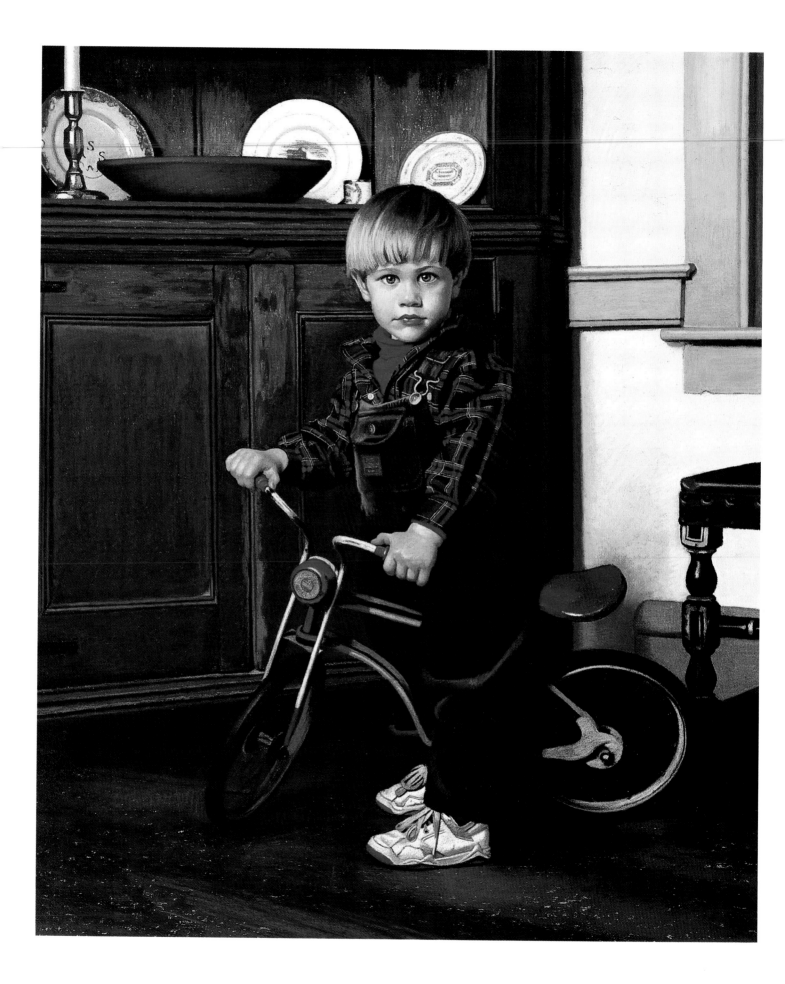

Section One

Preparing to paint a child's portrait

As an artist, I find the challenge of trying to capture the innocence and luminosity of a child's skin tones eminently satisfying. When I'm truly successful at meeting this challenge, I feel I've created a portrait that chronicles everything about the child at that particular moment in life — appearance as well as personality, temperament and even interests.

But in order to rise to the challenge of painting portraits of children, I must be prepared to engage and communicate. In the first three chapters of this book, I will explain how I go about engaging the child and the clients in the process, as well as how I communicate my needs as the artist. Being clear in my own mind, and then conveying that to my "partners" in this process, allows me to develop a solid concept for each new portrait and to gather the information I need to create it.

INCLUDING REVEALING DETAILS
Through research and discussion, I discovered that Judd's grandparents, who commissioned this portrait, have an extensive collection of folk art. I was delighted to incorporate pieces from their collection into "Judd", 30 x 25" (76 x 64cm). Note how the rough texture and blue-green color of the cabinet contrasts beautifully against the warm, smooth tone of Judd's complexion.

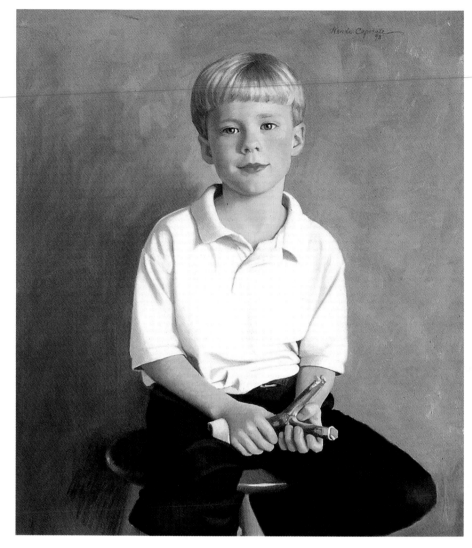

PREPARING THE SITTER
*The portrait of "Cameron", 26 x 22"
(66 x 56cm) was a companion to "Christian"
in Chapter 6, each of which were to be
three-quarter figure portraits. The children's
mother prepared them for their sitting by
taking them to their local museum to see the
portraits there. This was a wonderful way to
acquaint them with the process and allow
them to see this type of painting in an
historical context.*

Planning a new portrait

Every portrait begins with a first sitting. At these initial meetings, my goal is to become acquainted with my sitter, assist the client in making final decisions about the portrait and glean as much visual information as possible, using both photography and sketches.

Aside from studying the purely visual aspects of my sitter, getting to know my subject's personal style and demeanor is perhaps the most essential step in the first sitting. Gaining insight into what type of person I'm dealing with ultimately allows me to add my perception of their personality to the portrait. While some artists may choose to portray their sitters in a more enigmatic or mysterious way, I feel strongly about conveying the soul of the sitter although, granted, this is an intangible element. I strive for an emotionally charged image of my sitter and cannot accomplish this if I don't understand who they are. In other words, I don't just try to achieve a simple likeness, I aim for an in-depth one, which requires patience and study.

One of the more intriguing aspects of being a portrait artist is the opportunity to meet a myriad of personalities. Every experience with a sitter is unique. They each bring their own preconceptions and emotions to the process, so learning how to engage them is critical in making them feel comfortable.

MEETING THE SITTER
My first step is to find out as much as I can about my subject. In addition to getting some background information, I find that interacting with the model — whether briefly, as is often

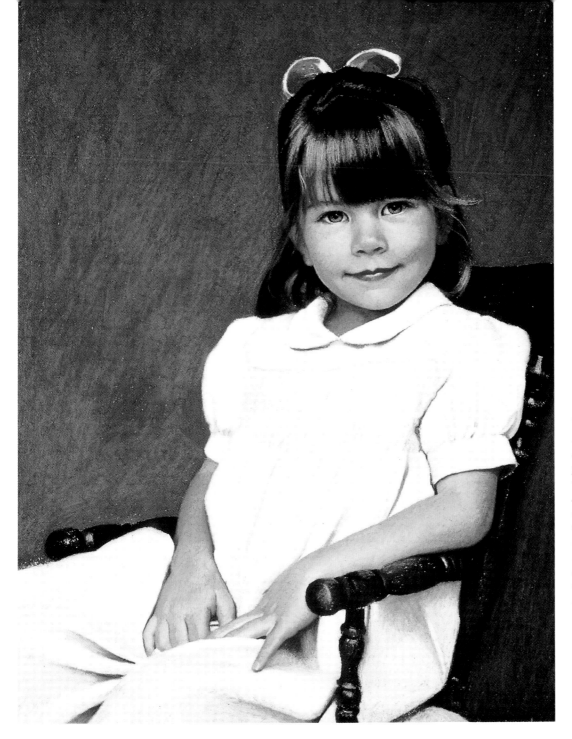

CONSIDERING PREVIOUS WORK
Danielle was the youngest of three girls. Her sisters had been painted by two other artists when they were five years old. Although each portrait was distinctly different, the common denominators were the size of the paintings and the size of the figures. Consequently, as well as measuring the outer dimensions, I measured the size of the heads in the other two portraits before creating "Danielle", 24 x 18" (61 x 46cm).

the case when I travel for commissioned work, or for a more prolonged period of time — provides valuable perception into my sitter's personality, interests and point of view. Much of this information can influence how I will approach the portrait in order to paint an encapsulated image of my sitter.

In my first meeting with a new subject, I immediately try to key into the person's style. When painting a child, I wonder how this child sees himself or herself and how I can incorporate these characteristics into the portrait. If a girl, for instance, prefers sports to more traditionally feminine playthings and she dresses accordingly, I would lean towards a more casual portrait. Forcing a child to do something that's totally uncomfortable is not only counterproductive, it can make my attempt to achieve an evocative portrait futile.

DETERMINING THE SIZE AND SCOPE OF THE PORTRAIT

Whether I am painting for myself or for a client, several additional decisions must be made. First, I must determine if the portrait will be formal or casual, which sometimes depends on the lifestyle of the sitter. At other times, the environment in which it will hang dictates the dimensions, and — since my portraits are usually just under life size — this will influence the amount of the figure represented, such as head and shoulders only, three-quarter figure or full-length portrait. This decision is largely up to the client, but if the price doesn't get in the way, the client may want my input as to how I envision the portrait. Finally, I must ascertain whether or not a detailed background is desired.

Other important considerations are the details and objects that tell viewers something about the sitter. Of these, clothing is perhaps the most important. Although I enjoy getting a child's input on clothing, I request a couple of different items in various colors to see what best suits the sitter, and what might be most interesting to paint both in terms of color and composition. For instance, a collar or flowing skirt can add an interesting element to the composition. At one time, I thought it was a bit presumptuous to select my sitter's clothing, but I've since concluded that this is an appropriate and customary thing for artists to do. After all, when Nelson Shanks was painting Princess Diana's portrait, he asked to see several outfits and ended up choosing from her vast collection of couture clothing!

When possible, I also like to include some other object that is personally relevant to either the sitter or the person commissioning the portrait. For example, a favorite toy or beloved pet often make a wonderful addition to a child's portrait. In one of my early commissions, I was asked to paint individual portraits of my clients' four grandsons. After some discussion, we determined that it would add interest to the portraits if some of the couple's extensive collection of folk art was included in the painting. Doing this was a natural way to personalize these portraits, and provided me with a delightful painting opportunity since I enjoy capturing the beautiful patina of fine antiques.

Occasionally, a new portrait is meant to hang with other portraits already in the family, so I must consider compatibility as well. In one recent case, my client already owned portraits of her two older daughters, both of whom were painted at the same age by different artists. I asked to see these at our initial meeting so I could measure the dimensions of the canvases and the size of the heads, which were roughly the same, to be certain mine would be consistent. In the same way, when I do individual portraits of several members of a family I make sure the paintings are similar and no one member stands out or dominates over the others.

When the portrait is commissioned, many of these decisions must obviously be made jointly by both the artist and the clients. This typically happens at the initial meeting. You'll find more information on how I work with clients in a commissioned situation in Chapter 13.

FINDING INSPIRATION IN RESEARCH

Once I have a rough idea of what type of portrait I will be painting, I like to start looking through my numerous art books for inspiration. I picture my sitter in my mind's eye and peruse various volumes on art to glean ideas. Often, a certain quality about a painting will pique my interest in connection with my model, such as the pose, color scheme or attitude. This quality frequently stays with me long after I have seen it and somehow finds its way into my work, if I am fortunate. Whether it is a particular color combination, the drama in the portrait, the way the figure is posed or simply the gesture of the hand, these researched images provide direction.

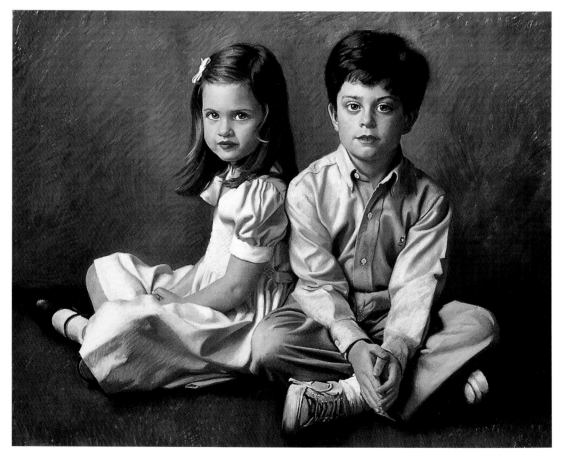

FOLLOWING MY INSTINCTS
This portrait, "Alex and Tierney", 30 x 40" (76 x 102cm), began and ended with sittings in our barn studio where the bank of skylights provided traditional Rembrandt-type lighting (see Chapter 2). This brother and sister were very close and the suggestion of them "leaning on" one another seemed particularly appropriate, although we tried a number of other variables, including using a small step-ladder to vary the heights of the figures. Here, I want to mention a compositional "rule" I chose to break: traditionally, two heads should never be at the same height, but in this instance I found the result quite pleasing.

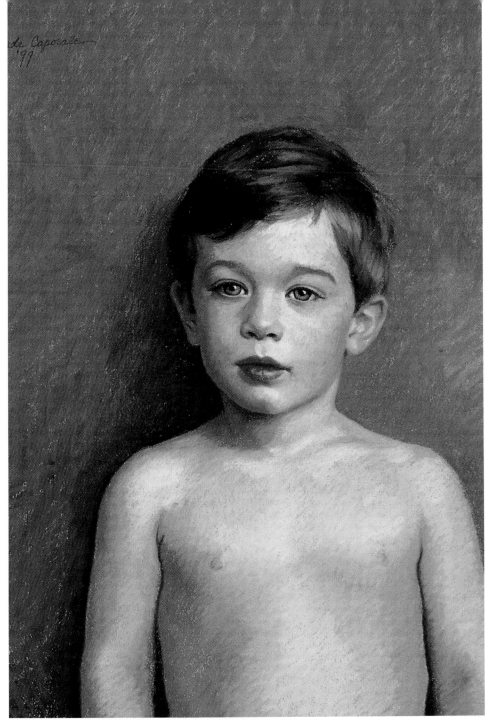

BEING NATURAL
*For the portrait of "Jesse", 20 x 16"
(51 x 41cm), his parents and I posed him
in several different shirts. But the most
natural photos of him turned out to be
when he was shirtless, because this is
how he feels most comfortable. This
highlighted his free-spirited personality
and resulted in a striking portrait.*

Even though I research options and envision the circumstances for my subjects, I rarely make sketches beforehand. I have found that my preconceived ideas rarely match or even come close to being as interesting as my sitters' natural gestures. Instead, I work with them, helping them pose in a way that is comfortable and that reflects their individual personalities. I do not want to inhibit my sitters with preconceived ideas, yet I maintain in my mind's eye the images I encountered in my research to see how I can incorporate them into these circumstances.

DECIDING ON THE SETTING
If I intend to paint a straightforward portrait in my studio, the setting is quite easy to handle. I usually start by positioning the model on the model stand in front of a neutral-colored backdrop that will either harmonize or contrast with the dominant color present in the model's hair, skin tones or clothing. I have a number of drapes in different colors, as well as a collection of interesting chairs, including a child-size chair, for the model to sit in. I select an appropriate drape and hang it from a metal screen, then bring in

Enlisting the parents' help

When I am photographing children, I initially ask the parents to be involved. It is important to get their input on the expressions they feel are most typical of their child. With a very young child, it is also helpful to have the parent present to help engage and encourage the child to cooperate. However, sometimes the child is less distracted, and more cooperative, without a parent watching. The parent is usually aware of this and will quietly leave. If not, I will tactfully ask the parent for some time alone with the child.

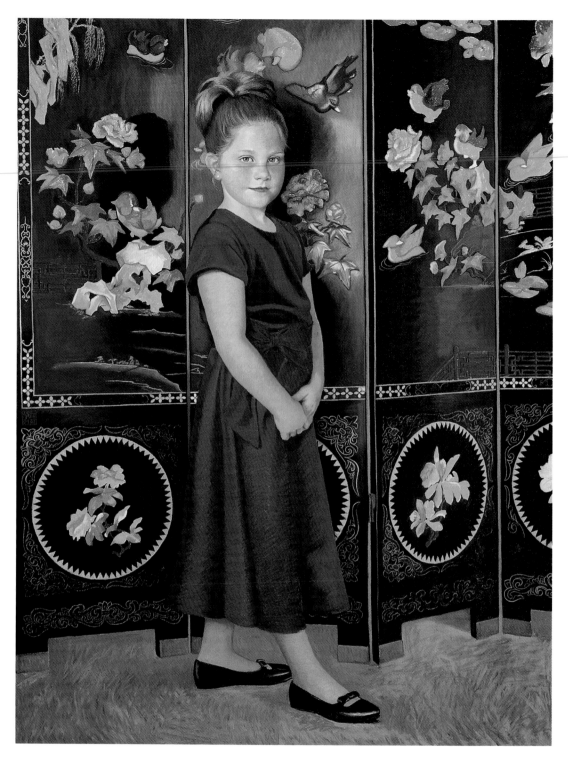

SPOTTING THE
PERFECT BACKGROUND

This portrait of "Alexandra", *48 x 36" (122 x 92cm) was to be full length from the start. When I arrived at the clients' home and saw the beautiful oriental screen, I felt it would make a dramatic backdrop for the portrait. When I returned for the final sitting, I spent equal amounts of time working with Alexandra as I did on the screen's complex design.*

Learn to watch your light source

Although I occasionally use professional artificial lights when working with a photographer, I prefer to involve natural light. Light from a north-facing window is the best source, but it isn't always available. Southern light is my second choice, before an east or west exposure. Fortunately, since the objective is to obtain photo references, the changing light is not nearly as problematic as it would be when working from life.

If you find yourself limited to relying on natural light alone, be aware that the light will change rapidly. You may select a south, east or west window you feel is perfect, only to return to it an hour later and find it is either too bright or too dark. Just be aware of the inevitable changes, learn to watch your light source and shoot quickly when the time is right in order to minimize the problem.

one or more chairs so I can create a variety of settings.

However, with most of the children's portraits I do, I have to start my work in the child's home. In these cases, preparing to work with the sitter can become a bit more complicated since the light source and the appearance of the setting are both important considerations. I typically start these sittings by requesting permission to roam about the house, looking for the best light source, preferably a north-facing window. This is when a compass comes in handy. I may eventually supplement this light with artificial lighting (explained in the next chapter), but I prefer to work with soft, diffused north light because it remains the most consistent over the course of the sitting. (In the southern hemisphere, a south-facing window would be required for the same effect.)

If some type of background other than a neutral color is involved, I also look for the best, most attractive places to position the sitter. Otherwise, I will hang a background drape from three compact, portable light stands I carry with me and secure it with clips. Not only does the drape provide an enclosed space for the sitter that controls the light and keeps it coming from a single direction, it also eliminates extraneous details in my photos so that I'm not distracted later when I'm painting the portrait.

At this point, I find or ask for various chairs, stools or benches to see what might be comfortable and seems to work best visually. In a head and shoulders portrait, the seat is fairly unimportant — a simple bench will do — but a chair can make an enormous difference in the composition of a three-quarter length or

full-figure pose. A chair can set the mood for a portrait and will lead to a variety of compositions when placed at different angles.

MOVING TOWARD THE PHOTO SESSION

By the time I have determined the size and style of the portrait, gleaned a few ideas from other resources and chosen a setting and backdrop, I am prepared for my initial photo session with my subject. Since most children find it impossible to sit for long lengths of time, I find that photographs, in conjunction with sketches, are the best means of creating a portrait of a child. These are supplemented by a final sitting on delivery of the portrait. In the next chapter, I will explain how I pose, light and photograph my young subjects.

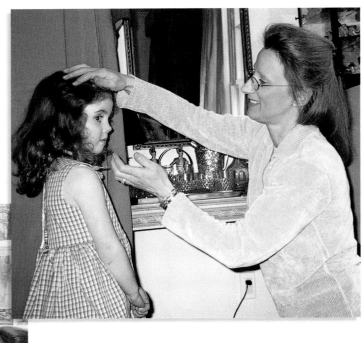

PREPARING TO SHOOT REFERENCES

When photographing my young subjects in their homes, I try to use natural light from windows as much as possible. I can supplement it with artificial light if necessary, but I prefer the soft effects of natural light. I position the sitter in front of a drape or some other background setting and take numerous photographs for reference.

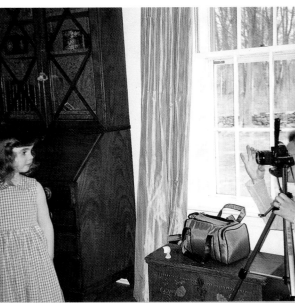

Use lights and cameras to your advantage and you will get the most informative and flattering reference photos of your subject.

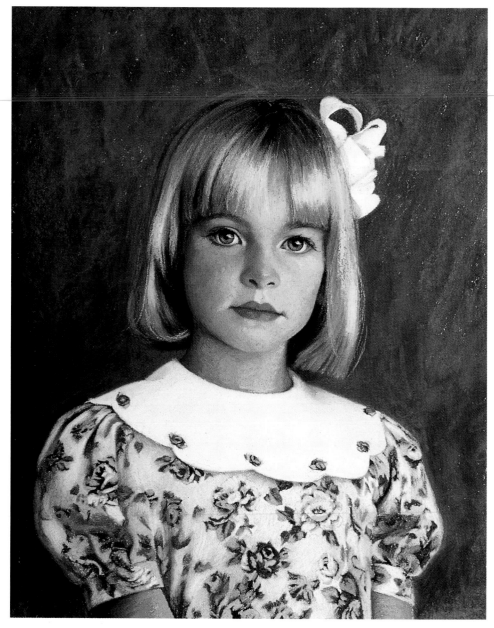

ADDING DRAMA WITH LIGHT
This was an attempt to do something a bit unusual. I used light coming in from French doors to the right for the portrait of "Christine", 20 x 16" (51 x 41cm). My sitter was turned very slightly away from the source, resulting in a minimum amount of shadow on the left. Her dress, particularly the scalloped collar, provided a wonderful shape to anchor the "pyramid" of her head and body, and its color beautifully offset her skin tones.

Lighting, posing and photographing

ecause children find it difficult to sit still for any great length of time, the best way to paint young subjects is by using reference photographs. That is why I devote a significant amount of time to taking professional-quality photographs during the first sitting.

However, although photographs do document quite a lot of information, they only provide the encapsulated view from the single lens of the camera. Very often when I examine the photographs, I'm initially disappointed. The image that my sitter presented to me is always more exciting than that recorded by the camera. No matter how sophisticated the equipment, my mind's eye sees a different picture. That's why studying my subject face-to-face, and noting the colors and

continued on page 21

(RIGHT) FILLING IN WITH AMBIENT LIGHT
The light source for "Ali", 20 x 16" (51 x 41cm) was a window in her family's home. The room had sufficient ambient light to negate the need for a fill card. The light source was further away than I usually prefer, which resulted in a softer fall-off and less distinction between the light and shadow. Fall-off means the sharp contrast between the lights and the shadows, defined by crisp edges.

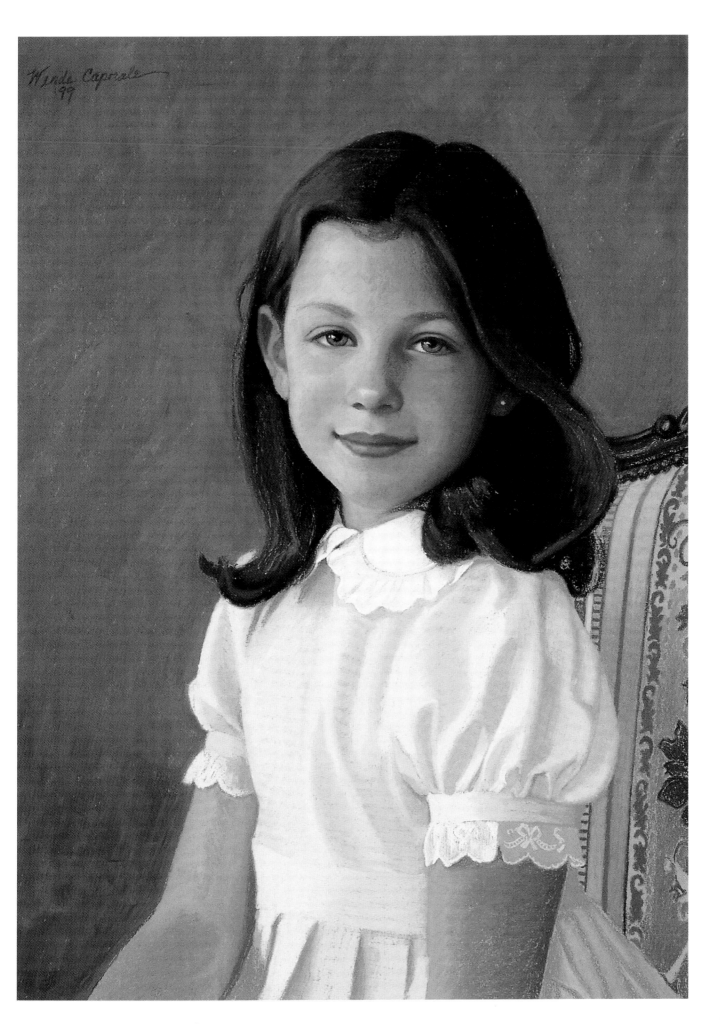

Different types of lighting

I had this series of photos taken to show the variety of effects achieved when you make adjustments in the direction and angle of the light source.

Upstage, or Rembrandt Lighting: An angled light on the left at the 10 o'clock position, creates a flattering look with gradual fall-off.

Vermeer Lighting: Here, light comes from the left at eye level, creating a different, but pleasing, effect.

Downstage Lighting: Light from above the shoulder on the right forces us to "read" the portrait in an unusual way, creating drama for the viewer.

Halloween Light: This type of lighting from below looks particularly garish when used in a classical portrait.

Light effects from different distances

This series of photos shows how changing the distance of the light source, and its intensity, can cause dramatic differences in the model's appearance.

When the light source is very close to the subject, it creates a sharp fall-off, meaning there is a sharp contrast between the lights and the shadows defined by crisp edges.

Positioning the light source at a greater distance from the model creates a gradual fall-off in which there is minimal contrast, softer edges and less definition in the forms of the face.

A bright, tightly focused, direct light source flattens the features and minimizes the definition of the forms, making it very difficult to paint from.

A large, diffused light creates a more gradual fall-off, although if the light is too large and diffused, the shadows will become too soft to define the features clearly

TAKING A TIP FROM VERMEER

In posing "Louisa", 16 x 14" (41 x 36cm) for her portrait, I was delighted to find this three-quarter view effectively highlighting her lovely features. This is what I call Vermeer lighting. Light comes in from the side, illuminating my sitter's back and creating a "raking" light across her head.

continued from page 16

forms in sketches, gives me an added dimension that I can hopefully incorporate into the portrait. Sketching forces me to slow down and study my sitter's demeanor.

Gathering this many references may seem like overdoing it, but I rarely have the luxury of seeing the child again until the final sitting. At the easel, I have nothing more to go on than my photos and sketches. So I've learned to help my sitters find graceful, natural poses, and I use modern technology to light and photograph them. Doing this doesn't require a lot of special skills or equipment. It's simply a matter of training your eye to find a pleasing balance of light and shadow and learning to work with the tools.

UNDERSTANDING LIGHTING

Light is one of the most important components of painting and it can be used effectively to add visual interest to any scene. However, in traditional portraiture, light is generally used to illuminate the subject's features, not to create intense drama. There are three important light source variables that can be controlled to enhance the model and the portrait. These variables are direction, angle and distance or intensity.

- Direction. Our eyes automatically go to the brightest parts of a picture or scene first. Then they travel to the shadow areas for further information. Furthermore, those of us raised in a western culture are accustomed to reading from left to right, so we find it easier and more pleasant to read a picture from left to right. This explains why most of us prefer a portrait lit from the left. This standard approach, often referred to as "Rembrandt" or "Upstage" lighting, casts a soft, diffused light across the left half of the face and illuminates the right cheek and eye in a soft triangle of light.

 It is perfectly acceptable to light a portrait from the right as well, but when our eyes are forced to read from right to left, we interpret it as moderate tension. Called "Downstage" lighting, this can be used effectively

to create drama, make a subject look more imposing, lend a figure more authority or create more impact.

- Angle. The height of the light source is another variable in creating drama. Again using Rembrandt lighting as the standard, a light source coming from the 10 o'clock position or slightly higher, but not directly overhead, creates the most pleasing effect. Light coming from an eye-level source, such as a window, is another option. The 17th century artist Jan Vermeer used this to great dramatic effect. Light shining up from below the horizon looks surreal. It is sometimes referred to as "Halloween" lighting, the implication being that the light source coming from below the horizon is "unearthly" looking.

- Distance. A third variable is what is known as "fall-off". This is how fast, or over what distance on a subject's face, the lighting fades from bright to dark. Fall-off is controlled by the distance between the subject and the light source. In typical Rembrandt lighting, the light source is just outside the frame of the picture or roughly three feet away, creating a sharp fall-off. This is most desirable because it clearly defines the features and shows the distinction between light and shadow.

For group portraits, the ideal lighting should be set at a distance twice the width of the grouping. So if the group is five feet wide, the light source should be ten feet from the nearest person. If you don't use this rule of thumb and set the light source closer to the group, the nearest person will be lit much brighter than the person at the back.

Directly related to the distance of the light source is its intensity, which is often influenced by the size of the light. A bright, tightly focused, direct light source, including clear sunlight, will flatten the features and create the hardest shadow edges, which is unflattering in a classic portrait. A better choice is a large, diffused light source that softens the shadow edges.

REED

SCOTT

Working in the sun

When working outdoors in bright sunlight, you can provide a softer, more flattering light by positioning the subject just within the shade of some object such as a tree or a house, or the soft box itself. Then "return" sunlight to the shady area with an artificial light source, such as the soft box.

In this way you'll achieve modeled, Rembrandt lighting in the foreground while retaining a sunny background.

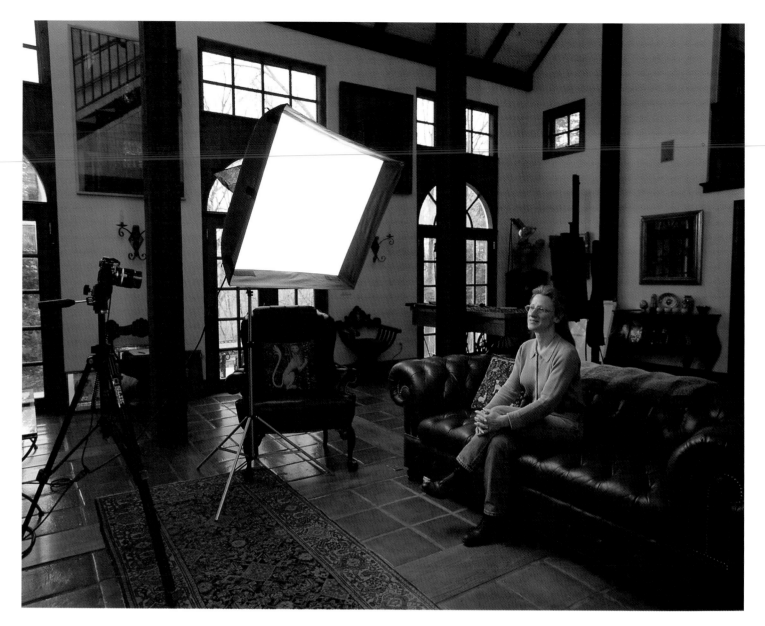

LIGHTING THE SITTER

When I set up a photo shoot with a child, I consciously keep these variables in mind.

If we are at my studio, I ask the child to sit or stand on the model stand, which brings the child up to a height that's comfortable for me to view. I then move the model stand, which is on wheels, and position it appropriately under the bank of windows because natural light results in a much more pleasing effect.

If we are working in the child's home, I still prefer to use natural light whenever possible. The ideal situation is a north-facing window with a consistent, diffused light coming from an angle at or above the shoulder. I usually position the child so the light comes from my left, but sometimes I work from the other side. Just as I do in the studio, I look for an interesting pattern of light and shadow on the head, figure and hands that will define and enhance my sitter.

If the natural light source is fairly good, I rarely need any other equipment than a "fill card". This is a white or gray lightweight board or cloth that I position on the opposite side of the light source to fill in some light on the dark side of the subject's face (see opposite). The closer and larger the card, the more light and detail will be brought into the shadows, providing more information for me to work with when I paint the portrait.

As the photo shoot progresses and the child takes different poses and positions

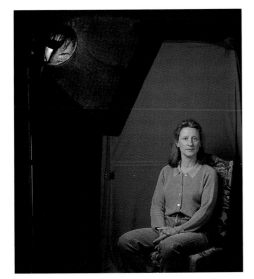

FILLING IN THE SHADOWS
Under a single artificial light source, the shadow side of the model's face is quite dark. By bringing in a "fill card" opposite to the light source, light can be bounced back into the shadows, revealing more definition and detail in this area.

in front of the light source, I frequently check how well the light is defining the features. With enough patience, I can make almost any interior or exterior setting work, and the result is a wider variety of reference images I can use.

I should point out here that I do not use the flash attachment on the camera itself. Too often the flash eliminates the sculptured appearance of the head, resulting in flattened images that are difficult to work from.

ADDRESSING SUPPLEMENTAL LIGHTING NEEDS

When working with multiple subjects for a single portrait, or when photographing more than three people for individual or more complex portraits, I hire a professional photographer. Because I am not equipped with a large format camera which can provide a large negative for more clarity, I prefer to have a photographer handy who can concentrate solely on the more complex technical aspects of the shoot. This allows me to act as an "art director", setting up my subjects, suggesting poses and expressions and, if posing them for a group portrait, making sure they interact in a way that will make an interesting composition.

A photographer also brings the lighting equipment required for more complex situations, including a variety of lights (at least two each of either tungsten "hot" lights or strobes), "soft boxes" or diffusion screens and light

stands capable of extending to seven or eight feet to hold them.

Tungsten lights and strobe lights are the two commonly used types of lights. Tungsten lights are very warm and are designed to be used with tungsten film. The advantage of strobe over tungsten lights is the ability to "freeze" action, for instance, children's expressions or movements, or that of pets or for "action" shots, such as dance poses, and so on. The disadvantage is that a Polaroid camera, or Polaroid camera back, is usually needed to see or "read" the lighting from strobes accurately. Though this is an extra cost, it is useful for previewing any type of lighting situation or composition.

A soft box is a "box" made of black fabric with a white fabric "face", which is placed over the light source to diffuse the light. The interior has a silver lining, which replicates north light. The larger the box, the softer the shadows become. Also, the size of the soft box should roughly match the size of the subject area. For instance, a single portrait with average background size is usually about three to four feet, so a soft box measuring 2 x 3' or 3 x 4' placed roughly three to four feet from the subject recreates the standard look of Rembrandt lighting. For a group portrait, a light box or diffusion panel of 5 x 6' at a distance of 6' or 8' creates the same feel. In lieu of soft boxes, any white surface, a wall, ceiling or bed sheet with a light "bounced" off its surface will do.

SETTING UP THE CAMERA

With the lighting situation settled, I can set up my camera equipment. I prefer to use a 35mm camera with easily adjustable manual settings. The best lens for shooting portrait photos is a short to medium telephoto lens, such as an 80mm to 120mm lens. I also bring along many, many rolls of film (usually PPF 400NC), as well as a stash of extra batteries. This combination of a lightweight, portable 35mm camera and fast 400 ASA film is ideal for capturing a child's quick movements and for gaining clear reference photos.

I secure the camera onto a steady tripod to insure that all the photos will be as clear as possible. For a head and shoulders commission, I usually put the camera at my sitter's eye level, approximately four feet away. If I place the camera higher, I will be getting more of the crown of the head which I do not necessarily want; if it is placed lower than my subject, it will have the tendency to lengthen the head but will also expose more of the underside of the chin and nose. I am often tempted to get closer than four feet, but this inevitably causes distortion so I stay back and use the zoom lens instead. When photographing more of the figure, such as a three-quarter figure or full view, I place the camera towards the middle of the figure, again in an effort to minimize distortion. A light meter helps me determine what settings to use on the camera to get optimum results. Finally, I am ready to shoot the photos.

POSING AND PHOTOGRAPHING THE MODEL

As I work with the child, I continually engage them in conversation to take their minds off what we are doing. This will help them overcome any nervousness or awkwardness so they can start to relax and pose more naturally. I usually have several poses in mind before we begin, and I continue to suggest both standing and seated possibilities over the course of the sitting.

Looking through the lens of my camera before I take the first shot, I am particularly concerned with the overall composition. I want to make sure that the shapes within the body and background are pleasing to look at and that they lead the eye into the focal point of the face. Simultaneously, I keep an eye on the patterns of light on the clothing and make sure any fabric folds fall in an interesting way. This is a critical point because the pose of the hands and clothing can either beautifully enhance the composition or destroy it altogether. Even if I am shooting for a head and shoulders only portrait, I generally pose the hands so that the shoulders fall naturally.

Once the child has settled into a pleasing pose, I ask them to look directly at me. I then ask them to slowly turn their head toward the main light source but keep their body in a fixed position. I ask them to pause several times along the way so I can shoot photographs. Each time the child turns a little more towards the light and stops to allow me to shoot a few more photos, I may suggest a small adjustment, such as the tilt of the head, a different smile or expression, the angle of a shoulder, the position of the body or just an arm or hand, and so on.

As much as possible, I strive to get all of the elements in the right place in one shot, a process I refer to as "art directing" or "composing through the camera". Several failed attempts have taught me not to waste time documenting a model in an environment unless I'm fairly sure the resulting photograph will provide everything I need to create a pleasing image. By setting things up correctly before I shoot the photo, I can avoid having to combine several images, which often results in a contrived composition.

When I have exhausted the possibilities of a particular location and have photographed the model in every position in relation to the light source, I suggest another approach at a different location. I may repeat this process several times to widen my choices. Changing positions and places also allows the child to take a break. But I try to make the breaks brief, particularly for young children whose attention spans are short. Frequent short breaks, and a good deal of bribing, usually work well with younger sitters.

Usually, for a head and shoulders portrait, I take a minimum of four 36-exposure rolls of 400 ASA color film, although it can be more, depending on the situation. I spend approximately 90 minutes per person, slightly longer if the portrait includes more of the figure, or an ornate background. This may seem like too much, but film is inexpensive and the results are well worth my time. Since this initial sitting is usually the only significant amount of time I spend with my sitter until the very end of the portrait, it's important to get everything I need to work from at this stage.

WRAPPING UP THE SITTING

Before ending the initial sitting, I like to make a charcoal sketch of my subject, including written notes and/or a color sketch about the coloring of the eyes, hair and complexion. If the child is quite young and simply isn't up to posing any longer, I'll make my sketch as the child watches television or plays quietly.

I like to get the photographs developed as soon as possible, just in case I need to shoot more before returning home to my studio. But with such a thorough approach to the photo shoot, I generally end up with plenty of high-quality references. Armed with these photos and my notes, I am ready to begin painting.

Is modern technology right for you?

For the past few years, the electronics industry has continuously rolled out all sorts of new camera equipment, including digital cameras. These cameras are getting pretty close in quality to traditional cameras and they have the added benefit of being compatible with computer programs which can be used for manipulating images. But until the digital quality improves and the price comes down, I choose to stay with my traditional 35mm camera, zoom lens and 400 ASA film.

Searching for that something extra

I hope you agree that these photographs managed to capture an expression or feeling
quite out of the ordinary, and worthy of taking further.

PAIGE

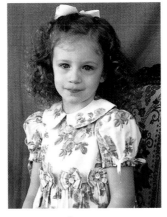

OLIVIA

LINDSEY

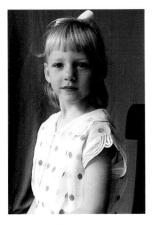

SOPHIE

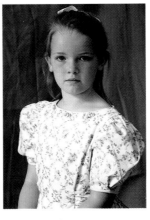

SARAH

MARGARET

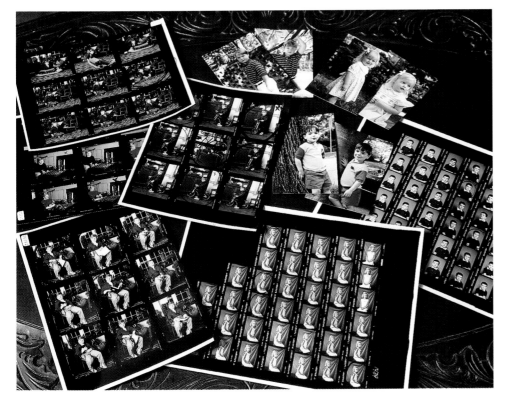

INCREASING MY OPTIONS

*By the time I'm finished with a photo shoot
and have had my pictures developed as
contact sheets or individual prints, I have
plenty of reference material to choose from
and work with. Almost any question I may
have about my sitter's appearance can be
answered by referring to these photos.*

Choose and arrange your materials in a way that allows you to be more creative and productive.

INCORPORATING TEXTURE
This portrait of "Maggie", 20 x 16" (51 x 41cm) was painted on a heavily textured board. I enjoy working with this type of surface because I think the beauty of soft pastels is shown to full effect.

Preparing to work in the studio

very artist needs a place to call their studio, whether it is a guest room, playroom, basement or a separate structure where materials and supplies remain undisturbed. Once a specific space has been set aside, you need to stock it with the best materials and equipment for the work you want to do. Having the right materials, and getting them organized in your special space, will not only allow you to be more productive, it will make your portrait painting experience all the more enjoyable.

DESIGNING YOUR STUDIO
Most artists agree they are far more likely to work regularly, and for longer periods, if they have a designated space where materials can be set out, waiting to be used at a moment's notice. I am fortunate to have a space designed in the tradition of an artist's studio with tiled floors, high ceilings and a wall of north-facing French doors, which is a comfortable and inspirational place to paint. However, I have many artist friends who have managed to carve out studios in unlikely places so they can

always get right to work. One uses the dining room of her New York City apartment and another works in her living room, using her easel as the central, most commanding element of the décor.

I believe the ideal room for a studio has a north-facing window for consistent light. However, because it is possible to simulate north light with supplemental lighting, any room will do. My previous studio, for example, had south-facing windows so I put in track lighting. A good set-up is to have three

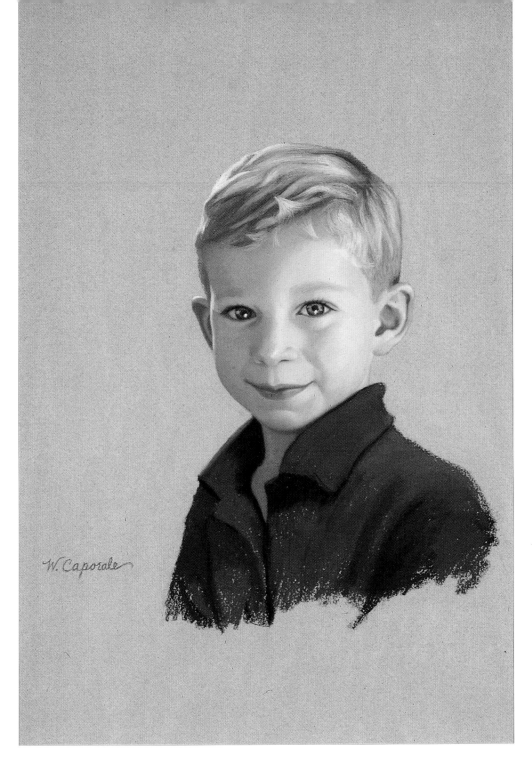

W. Caporale

photographer's light fixtures, each equipped with north light bulbs — one for the model or subject, another on the taboret or table holding the materials and a third for the easel. A studio with north light doesn't demand additional lighting, but it is useful for maintaining a more consistent light and working into the evening hours.

In addition to a light source, a studio should be outfitted with an easel, a stool, a model stand approximately 18" (46cm) in height (presuming you will at least occasionally be working from life, which is highly recommended) and a taboret table to hold the various sets of pastel colors and other small painting items, including a sketchbook, paper towels and surgical gloves for protecting hands. My taboret has a broad surface for holding several sets of pastels and three drawers for the extras.

The antique furnishings my husband acquired years ago have become storage space for additional materials, and second-hand architectural files house finished or in-progress works. Other studio items include a selection

ARRANGING MY WORK SPACE

The living room of our home doubles as my studio. You can see how I seat my models in a chair up on a model stand, which allows me to view them at my eye level. I keep my easel and taboret full of materials so that I'm always ready to work. Notice how my taboret is positioned between me and the model stand so that I can view my sitter and my color selection simultaneously.

☙ *Materials checklist*

Here is a list of the materials I suggest for equipping a portrait-painting studio:
- Easel.
- Taboret or table.
- North-facing window and/or at least three light fixtures with north light bulbs.
- Model stand with several chairs and/or benches.
- Stool.
- Background drapes in assorted warm and cool colors.
- Large set of soft pastels in a range of colors (darks, pure colors and light tints).
- Small set of hard pastels.
- Assortment of drawing papers and sanded panels in midtone colors.
- Sturdy drawing board.
- A dozen large clips for holding paper and securing background drapery.
- Small items: kneaded erasers, single-edge razorblades, charcoal pencils or vine charcoal, sketchbooks, a hand mirror, a wastebasket, paper towels and surgical gloves.

of background drapes in a variety of colors — grays, greens, blues and some warm reds and golds that will contrast with any skin tone — and a metal stand to hang the drape on. I also keep several chairs and benches in a variety of styles for my subjects to sit in or on, as well as a small selection of props (hats, scarves and the like) in my studio.

Last, but certainly not least, I recommend collecting all kinds of art books and keeping them handy. I constantly refer to my art library for ideas, such as the perfect pose, or an interesting juxtaposition of figures, or just for some needed inspiration to begin my day. There are two artists (and a budding third) in our home, so we keep our library in the family room where we have had lots of shelving

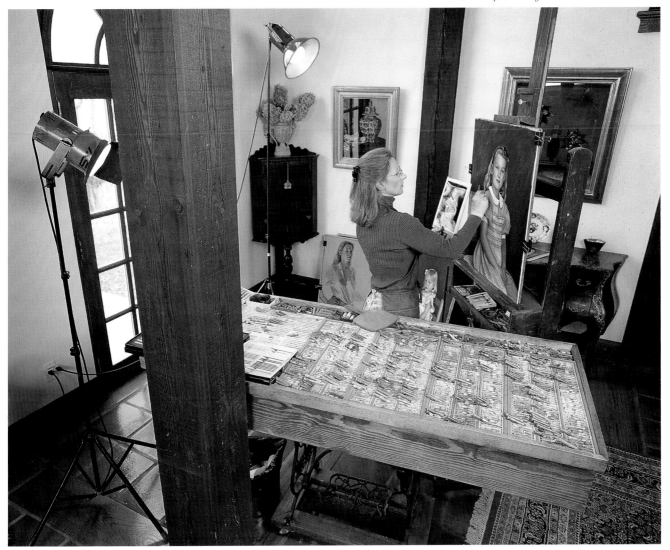

installed for this purpose. A large library table is where most of our reading or perusing occurs, although both my husband and I keep numerous books in our studios as well.

CHOOSING PASTELS
In my opinion, the versatile medium of pastel is ideal for portraiture, which no doubt explains its popularity with artists throughout history, including de La Tour, Degas and Cassatt. Since portraits require both the accuracy of drawing and the artistry of painting, it is exhilarating to work with a medium that can be used as a finely honed drawing instrument, then instantly turned on its side to create broad, brush-like strokes. Furthermore, there are seemingly limitless possibilities in applying the

medium, from broadly defined areas to richly textured layers and combinations of the two.

Of course, achieving any particular effect requires a thorough knowledge of the materials available, which will in turn dictate which pastels you decide to buy. If you're not already aware of this, you should understand that while many manufacturers make "soft" pastels, the brands vary considerably in their degree of hardness. Just to name a few brands on the market, Sennelier and Schmincke are by far the softest, NuPastels are considered the hardest, while Rembrandt and Unison are somewhere in between.

The best way to find the brands that suit your personal style is to buy small starter sets of several different brands

LIGHTING EVERY CORNER
From this angle, you can see the light sources that are aimed at my work area. Although the bank of north-facing windows provides a fairly consistent light, I sometimes find it necessary to supplement this with artificial lighting on my easel and taboret.

and experiment. Once you have found your favorites, you can then invest in an array of brilliant colors. Currently, my studio contains well over 600 softer pastels from three or four different manufacturers, plus a smaller array of very dark colors, which were previously not available in the other sets. Several manufacturers have recently released special dark sets. I also have a 96-stick set of very hard pastels and an assortment of pastel pencils, all of which I sharpen to points with a single-edged razorblade.

As you experiment with the pastels, you will find they can generally be used interchangeably, provided you proceed with a light touch. However, you may discover that soft pastels will fill the tooth of the paper too rapidly, which will prevent you from putting on additional layers. To eliminate this problem, you may want to try using the harder pastels first and saving the softer brands for later layers. Or, since this problem mainly occurs when working on paper, you may want to work on a properly prepared, textured surface. Other solutions are to spray workable fixative on the saturated area or to gently remove some layers with a razorblade to redevelop the tooth of the paper.

PICKING THE RIGHT SURFACE

Through the years, I have experimented with many pastel surfaces on the market as well as surfaces I have prepared myself, all in a vast array of textures and colors. For instance, at one time I mixed gesso, pumice and water and applied it to illustration board. I have also mixed grit material with gel medium and applied it to raw canvas, which I then stretched on stretcher bars or directly mounted on masonite board or illustration board.

Currently, I prefer to paint childrens portraits on fairly smooth drawing papers or larger sanded, polymer resin boards, both designed specifically for use with pastels. Although these surfaces have enough tooth to hold many layers of pastel, the smoother texture provides a nice foundation for the delicate skin textures of my young subjects.

I also prefer to work on a colored

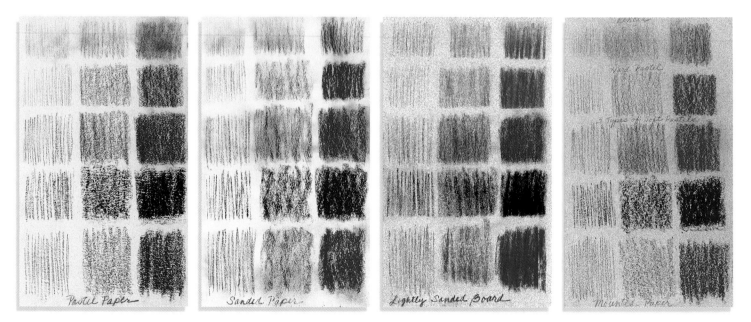

EXPERIMENTING WITH MATERIALS
Between the many brands and softnesses of pastel sticks, and the wide range of pastel surfaces on the market, I can achieve a rich diversity of effects. I think the best way to find what works for you is to buy individual sticks and sheets, then experiment until you find the combinations that you find satisfying.

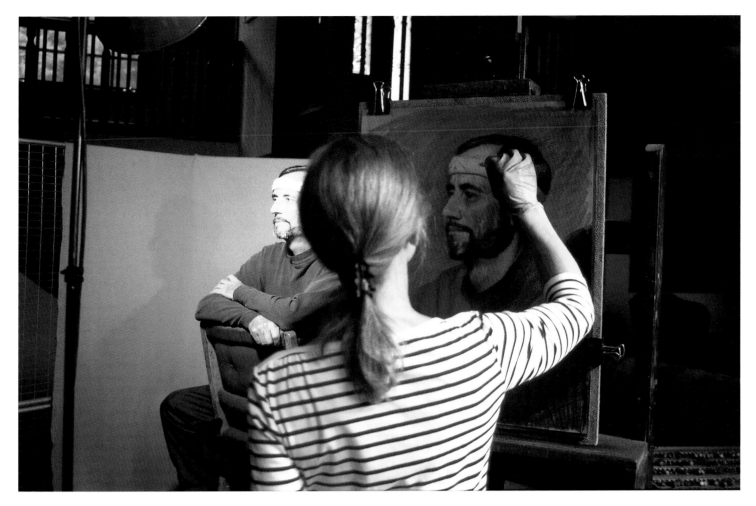

GETTING THE BEST VIEW
*When I'm working from life, I position my easel in a way that allows
me to simultaneously see both the model and my work-in-progress.*

Making a textured surface

Although I prefer to paint childrens portraits on smooth surfaces, I also like textured surfaces. This is the recipe I use to create a sand textured working surface:

- 2 parts acrylic gesso (2 tablespoons)
- 1 part grit or pumice, single F or double F size between 300-400 (1 tablespoon)
- 1 part water (1 tablespoon)
- Illustration board, 100% rag, acid free OR masonite panel, untempered
- Water-based paint (acrylic, casein, gouache, tempera or watercolor)

Stir the gesso, grit and water together with a large brush. Apply the mixture to the acid-free board or panel using horizontal strokes first, then vertical strokes. Let dry for 45 minutes. Tone with a combination of warm and cool water-based paints diluted with water. Do not mix water-based paint into gesso mixture because you will need too much pigment to create the proper midtone value. (Pumice is available at most hardware stores. Masonite boards are available at lumberyards.)

ENJOYING THE BOUNTY OF COLOR

When I first acquired this huge set of pastels, I could not imagine what I would do with all the colors. It has given me great enjoyment to continually explore the large array of possibilities. And, with the broad assortment of colors laid out on my taboret, I am always encouraged to experiment with a wider range than I would choose to mix if I worked with some other wet medium. For an artist who enjoys color, this is the ultimate delight!

surface which has a middle value, such as neutral gray, umber, green or burgundy. With a mid-value surface color, the dark and light colors immediately register against the middle tone. On a white surface, all colors appear darker than the surface whereas a colored surface makes it easier to see if the values are correct.

Experience has taught me to place my surface on the easel with the top tilted slightly forward. As I work, the excess pastel dust will fall away from the surface instead of ending up on the painting. I also prefer to work on a somewhat flexible, springy surface, rather than on a hard, slick board. The rich texture of pastel becomes more

apparent on a surface that "gives". So, when I'm working on a drawing paper, I usually clip the paper with six to eight sheets of paper beneath it to a sturdy backboard.

WORKING AT WILL

With my materials spread out on a taboret in my studio, surrounded by beautiful light and a stock of pastel surfaces, I can paint at a moment's notice. The added benefit of using a dry medium such as pastel is that I can easily stop to attend to my family or other business-related matters, then pick up and continue working. The right studio environment certainly motivates an artist to be both creative and productive.

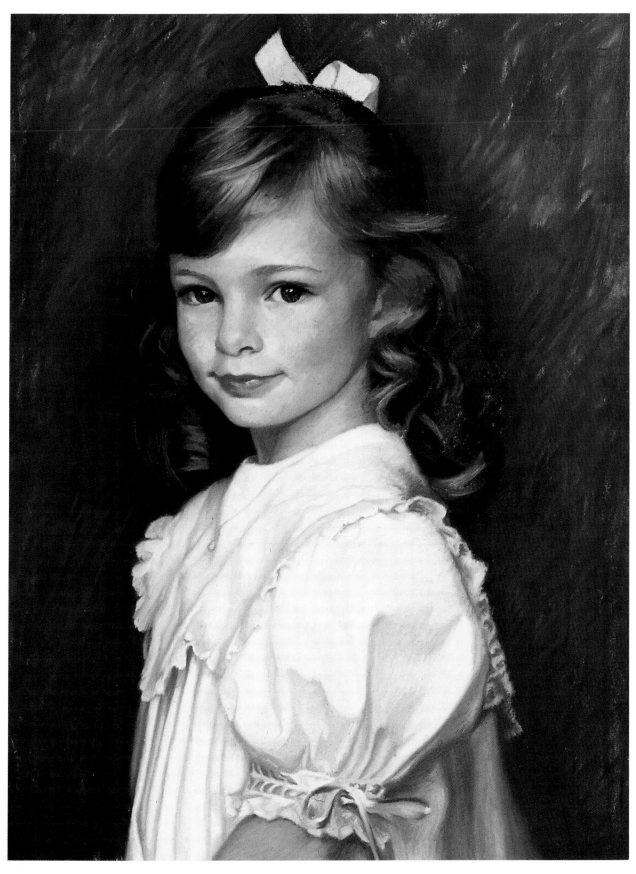

CHOOSING A SURFACE FOR EFFECT

I painted one of my portraits of "Lindsey", 20 x 16" (51 x 41cm) on a lightly sanded board made especially for pastel. The tooth allowed me to sufficiently build layers of pastel until the surface was saturated and I had achieved a smooth finish where I wanted one. I mostly used very soft pastels for this portrait.

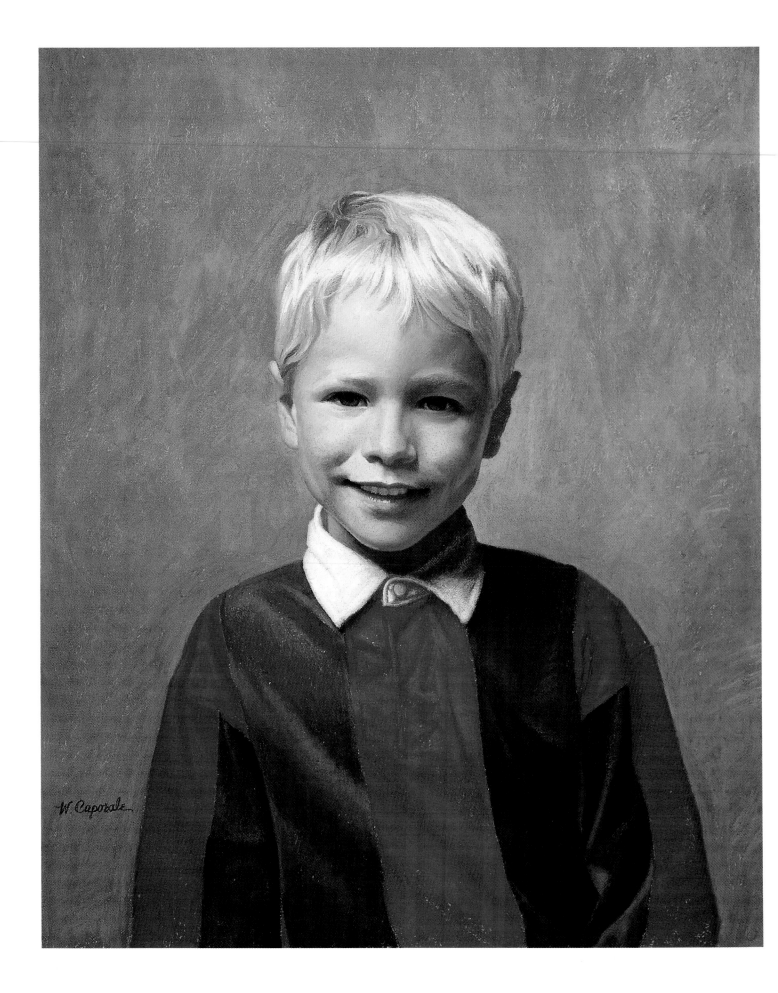

Section Two

Demonstrations: Creating a portrait

Children are particularly appropriate subjects for pastel portraits because the luminous quality of their skin tones can be beautifully achieved using pastels.

The following demonstrations illustrate how I use photographic references and working sketches to create a series of commissioned portraits of children. The final demonstration, done entirely from life, involves a professional male model.

In all of the demonstrations, my process includes a series of steps which remain consistent regardless of my subject matter. I begin by creating an intricate drawing on my working surface. This is followed by massing in the dark areas, then the middle tones and finally the lights.

The next step involves dealing with edges, either making them crisp or soft depending on where I want to lead the viewer's eye. In the final stage, I refine the portrait with details throughout.

While this method provides a consistent framework for my paintings, each portrait presents its own unique set of circumstances. Decisions regarding color, mood and the complexity of the composition make each portrait an individual work of art. In the following eight demonstrations, I explore some of the special challenges you might face while simultaneously showing and explaining my general portrait painting process.

CAPTURING MORE THAN A LIKENESS
This portrait of "Joseph", 20 x 16" (51 x 41cm) *was a joy to paint. It exhibits a straightforward pose using traditional Rembrandt lighting, and allowed me the opportunity to build up layers of pigment to achieve his smooth, luminous skin tones.*

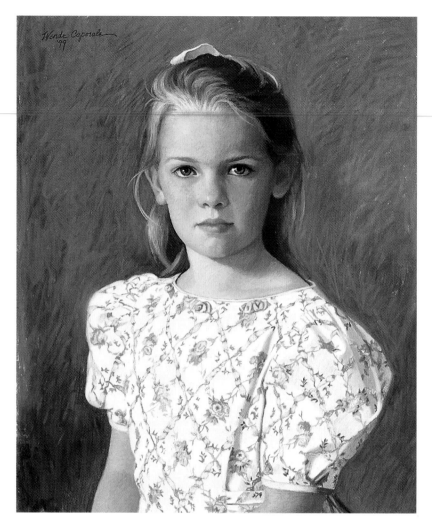

By experimenting with different poses and compositions, you'll find the most appealing ways to present your subjects.

COMPOSING WITH CLOTHING

For my head and shoulder portrait of "Sarah", 20 x 16" (51 x 41cm), *the wide puffed sleeves on her dress provided a beautiful broad base. Clothing can add a particularly interesting element to the composition. I think the angle of her shoulders, with the closest one tilted down, also invites you into the portrait and leads your eye toward her lovely face.*

Composing a portrait

I am often asked if I flatter my subjects. Although I would never alter my sitters' appearance to make them more attractive, I certainly do want to present them in the most appealing pose with lighting that enhances their best features. I try to emphasize the characteristics I feel are most attractive while downplaying any traits they may dislike about themselves. As a painter, I look for beauty and strive to bring out the beauty of my subjects. I can do this with light and shadow patterns, a particular color combination, a gesture or, hopefully, a combination of all of these.

When designing the head and shoulder portrait of Ricky on the following pages, I tried a number of different poses but eventually settled on one that had his body facing away and his head turned toward the viewer. You can see how the angled body — the three-quarter view — creates a narrow, triangular shape. In this instance, I also used a light source coming from my right rather than the traditional Rembrandt lighting from the left. Of the many places in Ricky's home where I photographed him, this lighting arrangement proved to be the most visually appealing.

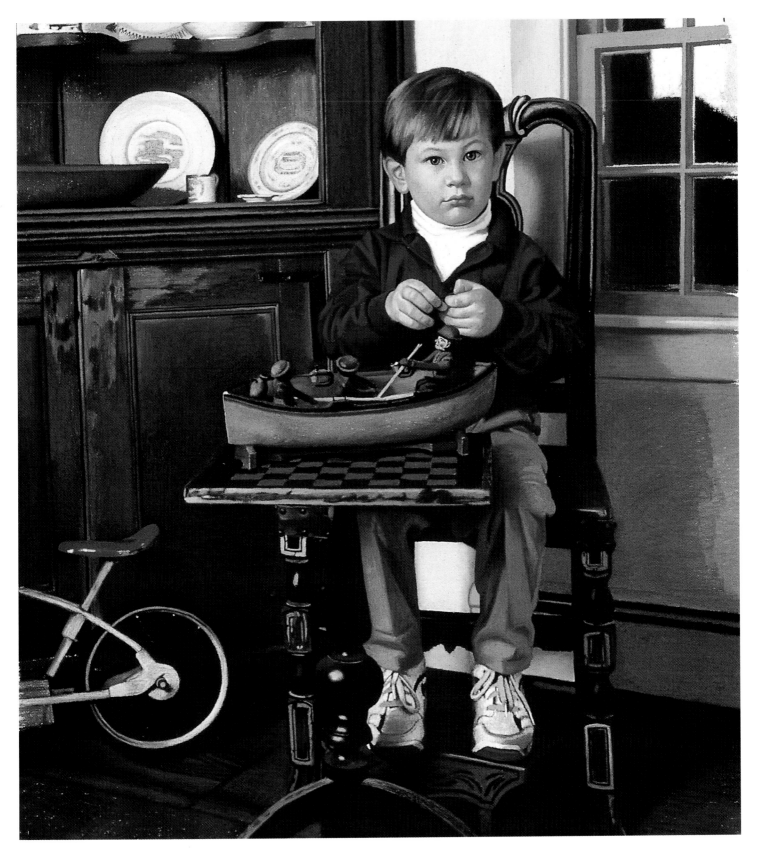

LEADING THE EYE

Composing "Scudder", 30 x 25" (76 x 64cm) was a challenge. With such an elaborate background, I had to make sure the figure remained the main focus. I positioned the elements so that the angle of the furniture and window would lead the eye to the center of attention.

Enlarging and transferring a drawing

Because accuracy is so important to me, I use a very careful, yet easy, method of enlarging my photo references to the full size of the portrait. In general, I enlarge the original onto a sheet of tracing paper, then transfer the full-size drawing to my work surface with graphite transfer paper. Here are the steps I follow:

1. I begin by reviewing the photo to determine whether I am happy with the composition exactly as it appears, or whether it needs to be refined by slightly cropping the top, bottom or sides. I then measure the exact portion of the photo I intend to use.

2. Using a proportion wheel, I determine the corresponding measurements of the final portrait. For example, let's say the photo measures 6 x 4" (15 x 10cm), and the portrait is going to be approximately 24 x 18" (61 x 46cm). I simply align 6" (15cm) with 24" (61cm) on the proportion wheel, and it will show an increase of 400%. But this tells that, at the same 400% increase, the 4" (10cm) edge would only enlarge to 16". So I conclude that my portrait size will be 24 x 16" (61 x 41cm). Before continuing, I verify that this increase will not make the head larger than life size; if needed, I scale down to a smaller size.

3. Once I know the measurements of the full-size portrait, I prepare a surface accordingly, adding at least one inch to each dimension to allow room for the mat or frame. In this example, the final size was 25 x 17" (64 x 43cm). I then cut a sheet of tracing paper to the same size.

4. Next, on a clear acetate sheet I create a grid with a 1" (2.5cm) scale. I place this grid over my photo and secure it all around so it does not slip.

5. Then I create a similar grid on my tracing paper — not my work surface — using the same number of squares as found in my photo reference. My photo would have a 1" (2.5cm) grid of 6 squares x 4 squares. Centered within my 25 x 17" (64 x 43cm) tracing paper, I would then draw a 24 x 16" (61 x 41cm) box and divide it into a grid of 6 squares x 4 squares. Each square measures 4 x 4" (10 x 10cm).

6. Once this is done, I carefully transfer whatever appears in each box on the original to the corresponding box on my tracing paper. I then stand back to review the drawing, making any necessary corrections resulting from distortion in the photos.

7. Finally, I place the prepared drawing done on tracing paper over the actual work surface. I lay a sheet of graphite transfer paper face-down between the drawing and surface, and secure them all in place. I then trace my original drawing onto the surface with a fairly sharp pencil or ball-point pen.

This method has been used for centuries to scale up drawings for large works and mural paintings. It is an accurate way to confidently transfer without lots of erasures on your pastel surface. Occasionally, I skip the tracing paper and work right on my surface, but I always proceed with extreme care to avoid erasures and excessive handling.

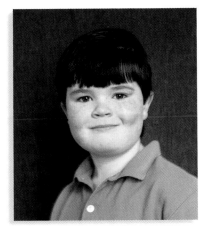

BE CAREFUL HOW YOU CROP
Cropping too high creates a square shape.

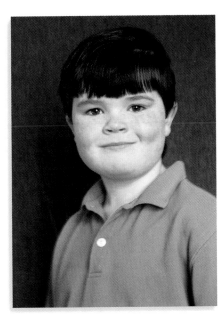

THIS IS A BETTER CROPPING OPTION

What size is the right size?

Portraits often are painted at life size or slightly smaller. This simple rule of thumb naturally dictates the appropriate size for the paper, board or canvas you use. I have found that 24 x 18" (61 x 46cm) is about the largest I can go for a head and shoulders portrait of an adult, and I work slightly smaller for a child. The only time I go larger is when an elaborate background has been requested. For a three-quarter figure portrait including hands, the range is 24 x 20" (61 x 51cm) to 40 x 30" (102 x 76cm). A full-length portrait can be sized anywhere from 40 x 30" (102 x 76cm) and up, depending upon whether the subject is seated or standing.

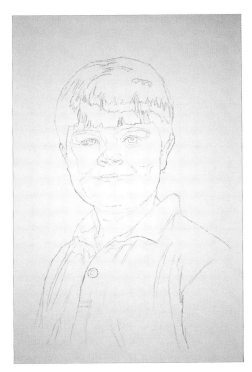

POSITIONING JUST RIGHT

I began Ricky's portrait with a detailed charcoal pencil drawing on a mid-tone gray sanded board. (See sidebar opposite.) Notice how I positioned the figure in a way that includes a generous amount of his torso. This created an overall shape that appears elongated.

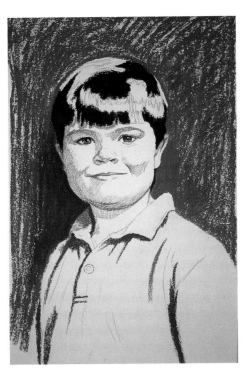

APPLYING HEAVY DARKS

To immediately establish the relationship of the background value and color to the figure's value and color, I started putting in the deepest darks in Ricky's hair and on the shadow behind his head. Using two values of indigo for the background and raw umber in the hair, I applied the pastel with a firm pressure to eliminate the grain and color of the surface and made a rich dark value. Recognizing other places in the portrait where these blues would work, I repeated them, plus some greener blues, to start the shadows in his shirt. Already I was beginning to unify the painting with color.

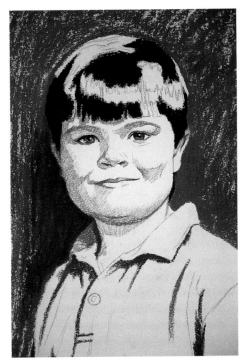

PREPARING THE SHADOWS OF THE FACE

This close-up shows how I also put in some of the dark values — the deep blue in the eyes, the warm brown around his face and ear and a more lifelike deep warm red in the nostrils and corners of the mouth. As you can see, I did not apply as much pressure to the pastels to allow much of the cool tone of the background to come through. This lighter application allowed me to crosshatch additional colors over these areas later.

39

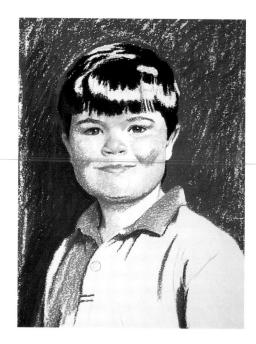

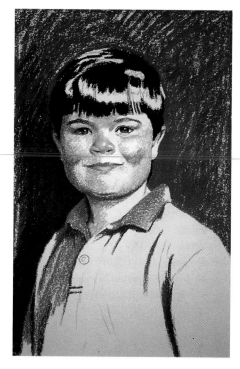

EXTENDING THE VALUE MASSES

Still referring to my photo, I continued massing in the values. I moved down to address some of the color in the shirt — adding turquoise, which works well with the indigo shadows — since these colors would help determine some of the colors for the head. Then, going back to the face, I began to lay a foundation of skin tones by integrating both warm and cool violets on the shadow side of his face, under the chin and along the jaw line. As I worked, I continually corrected my drawing to more closely capture the likeness of my sitter.

TRANSITIONING WITH MID-TONES

I think of the head, cheeks, nose, forehead and chin as spheres. To give them the gradual transition of values that makes them appear round, I applied mid-tone values between the shadows and the lights. Here I used cadmium red light and yellow ochre, again with a light touch to allow for later modifications in color or value. Notice how I used the most intense colors at this stage. It was the perfect opportunity to infuse the portrait with bright, rich, pure colors, not tinted with white or darkened with black, before moving into the light areas.

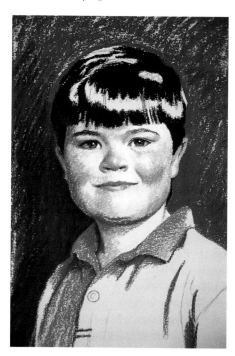

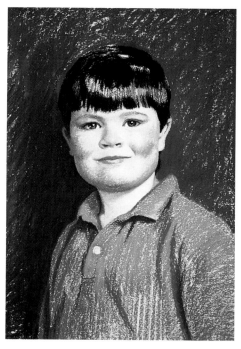

ADDING LIGHTER TONES

To complete the effect of light falling over a spherical object, I laid in the lighter values on his face (not the highlights) with a combination of light yellow ochres, cadmium red lights and warm and cool violets.

Before moving on, I brought some of the same deeper violet tones into his hair to help unify the tones in the face. Then I began to fill in the shirt with the same indigo and turquoise colors used previously, as well as similar

BUILDING THE SHIRT COLOR

blues and blue-grays from the same family for interest and variety. Initially I placed light, random strokes but then I applied a heavier build-up of pastel, changing colors and values to create the folds and volume of his body. I allowed some of the surface to show throughout his face and hair, not only because its underlying middle tone influenced the value of each area's color but also because it created a beautiful texture.

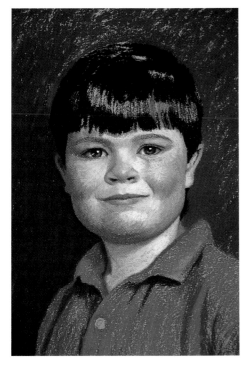

DETAIL

I treated the hair much the same as I did the face, modeling from dark to mid-tone to light. To balance the predominantly cool tones used previously, I added some warm notes of color to the light parts so the hair appeared dark brown rather than black.

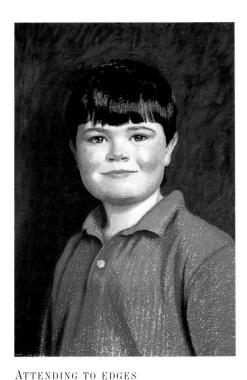

ATTENDING TO EDGES

Once all of my initial values and colors had been placed, I went over the entire painting, comparing values against each other for accuracy. For instance, I noticed that several areas of his face needed to be made slightly lighter in value, so I added more layers of color. As I made these subtle color modifications, I also attended to the edges, making them more crisp where I wanted the eye to settle and softer where I did not want to draw attention.

POLISHING THE RESULTS

Finally, I reviewed Ricky's portrait once more for drawing accuracy. Going over every area in minute detail, I continued to crosshatch subtle degrees of color, being certain to maintain the feeling of masses and of shadow versus light. This achieved the effect of blending, although I never used a tool or my finger to blend. Then I placed the highlights for the first and only time on "Ricky".

Why some compositions don't work

Although the process of choosing the best reference photo is somewhat subjective, there are usually solid reasons for rejecting others. Here are a few of the photographs I didn't develop into portraits and the reasons why.

No movement

Not only is there no movement in this pose, the lighting yields too little detail from which to work.

Too busy

The overly busy pattern of this sweater takes the focus away from the head. Also, because I didn't use a fill card, there isn't as much detail or information in the shadows as I'd like.

The patterns overwhelm the subject

With so much pattern in the clothing and background, the viewer wouldn't know where to look first. There was also too much light on her face causing a very gradual fall-off, which makes it difficult to see the forms of her face.

A "nothing" pose

This pose is too "frontal" and it has no action. Also, his clothing is bunched up in an unattractive way.

42

GIVING PORTRAITS A TWIST

*In this portrait of "Owen", 15 x 14" (38 x 36cm), I included a
child-size chair as a rich addition to the composition. I then
enhanced the sense of movement by choosing a pose in which the body
faced one direction while Owen's head turned in another.*

Seeing colors in skin

As you will see in all of my demonstrations, I use a tremendous amount of rich, saturated color to render skin tones, not just variations of "flesh tones". For example, I typically incorporate a variety of warm and cool violets, cadmium red lights, various alizarin tones, siennas, umbers and yellow ochres. For African-American subjects, I include a number of cool blues and purples. Colors that seem totally inappropriate in the box may be of value when put in the context of a portrait.

You can learn to see these colors in your portrait subjects, too, but you then have to be a little bold in applying them. Often you have to experiment to find the most compelling color combinations. Fortunately, pastels are the ideal medium for testing the limits of your palette because you can layer colors so easily. Broadening the range of colors you use to paint skin tones will capture a more realistic impression of skin, create the illusion of light and form, ensure a better balance of warms and cools and simply make the painting more visually appealing.

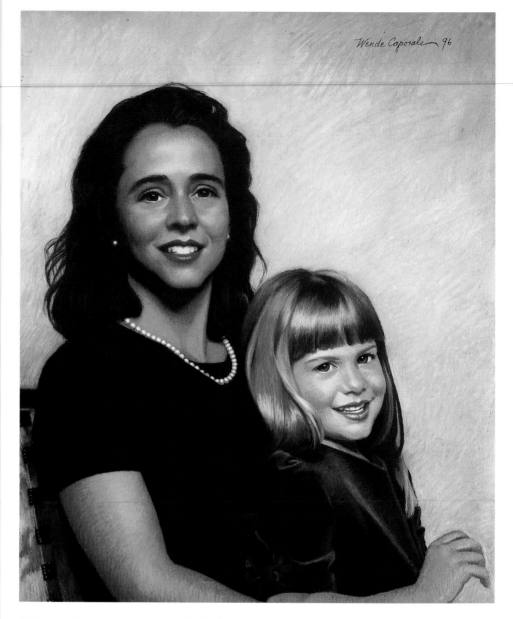

Naturally the vast majority of multiple-figure portraits involve people who are related to one another. When painting double or group portraits of families, such as "Caroline and Hannah", 24 x 18" (61 x 46cm), I try to design a composition that conveys a close relationship.

"I try to design a composition that conveys a close relationship."

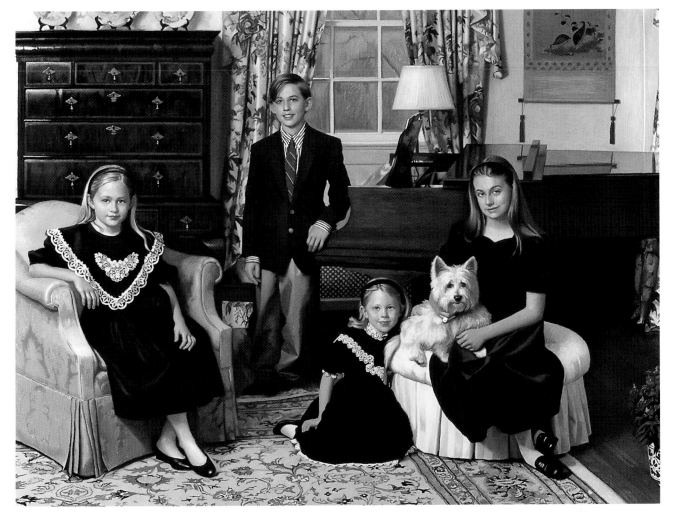

COVERING ALL THE BASES
*For "The Walker Children",
48 x 72" (122 x 183cm),
I worked with my photographer
who shot the photos while
I arranged my sitters. It became
clear as we were working that
this composition (which I saw in
Polaroids) was the one
I preferred. Therefore, I had
the photographer shoot a group
picture as well as individual
images of each child in position,
and a final photo of just the
setting to gain more information
on the details in the background.*

"IRIS AND BOB",
25 x 30" (64 x 76CM)

Inject more drama and
variety into your
portraits by using
different lighting
situations.

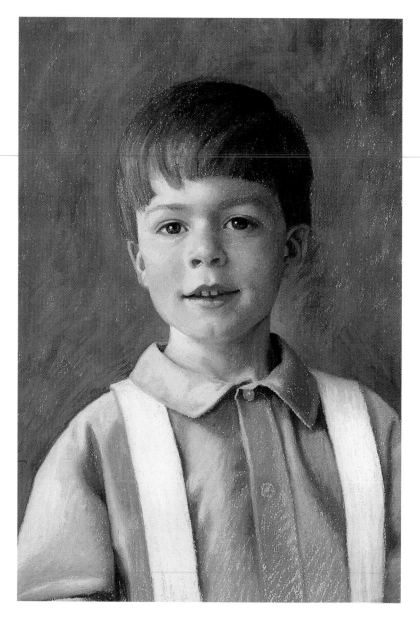

ENJOYING THE LOOK
OF VERMEER
*"Teddy", 18 x 14" (46 x 36cm) uses
Vermeer lighting. The light comes
from a window directly to the left. It
creates a full light on the left and a
raking light on the right,
illuminating the cheek in a warm
middle tone.*

Using Vermeer lighting

As I explained in Chapter 2, Rembrandt lighting coming from an angled skylight above the sitter's right shoulder has long been the standard for portraits. It is a wonderful, flattering way to light any model. But on occasion, I like to do something a bit different. Inspired by the breathtaking drama of Vermeer's paintings, I frequently like to position the sitter in an interior setting next to a single source of light from a vertical window. This light beautifully defines the features, as you can see from the demonstration and the rest of the examples in this chapter.

To achieve this effect with Peter, I began by seating him in his family's living room about four or five feet away from a south-facing window. The ambient light bouncing off the pale yellow walls of the room lightened up the shadows on his face, eliminating the need for a fill card. I positioned my camera and tripod about four feet from him, and used the zoom lens to get in closer without distorting the image. Looking through my camera's viewfinder, I noted that the light defined the nose and eye sockets with shadow.

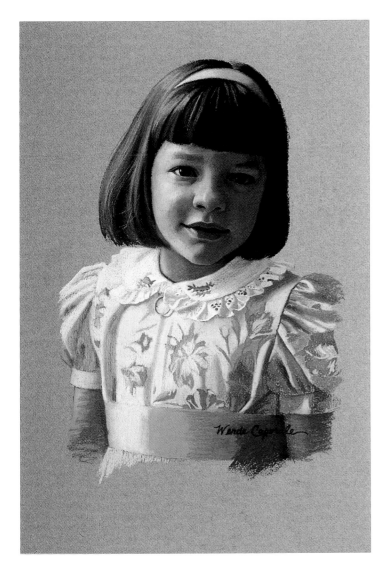

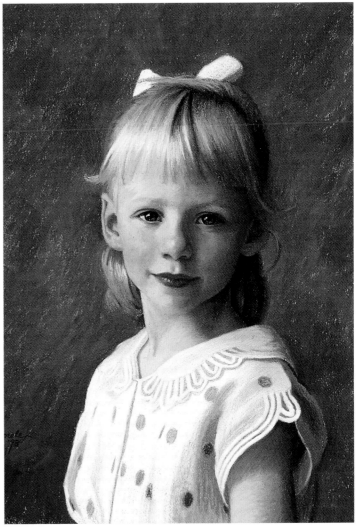

DEFINING FEATURES WITH LIGHT

"Abby", 16 x 14" (41 x 36cm) *was one of my earliest portrait commissions. Although I'm still quite pleased with the Vermeer lighting in this portrait, I've since moved away from using darker values in the shadows on the face. Most clients seem to prefer less shadow in their children's portraits.*

USING VERMEER LIGHTING

"Sophie", 18 x 14" (46 x 36cm) *is another example of Vermeer lighting. This portrait, along with "Teddy" on page 46, "Peter" and two others, were all painted for the children's grandmother, which is why I used similar lighting conditions for each.*

Having attended to all of the technicalities and ensured a soft, Vermeer-like light source, I began to shoot many photographs. I asked Peter to take a number of different poses, including a three-quarter view. For each pose, I asked him to slowly move his head in one direction and then back again, while I snapped photos at periodic intervals. To help the situation along, Peter's mother Amy and I had him imagine a butterfly and explained where it was flying so he could have something to focus on. This technique allowed me to obtain a range of beautiful expressions.

"Putting children at ease will circumvent the artificial smiles and encourage natural expressions."

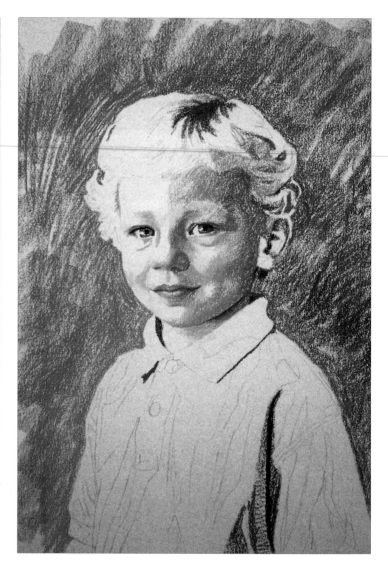

ENSURING COMPATIBILITY WITH PREVIOUS PORTRAITS

For my portrait of Peter, I began, as always, with a detailed drawing, this time on pastel paper. I chose this surface to match the previous portraits I had done of his two sisters and two cousins, all commissioned by Peter's grandmother. Before continuing, I made sure Peter's head was about 7" (18cm) high, so that it would be compatible with the other portraits.

APPLYING COLOR WITH A LIGHT TOUCH

Because the tooth of this paper can fill rapidly, I began with lighter applications of two rich blues in the background. Although I was fairly certain the values of these blues were correct, I wanted to allow myself room for adjustments in the later stages. I then placed the shadow colors and deeper tones in the head while incorporating the same background blues into his shirt.

Avoiding artificial smiles

Although children are usually less self-conscious and more animated in front of the camera than teenagers or adults, they still have a tendency to give artificial smiles. Even with somewhat older children, who are better able to follow instructions, it can be difficult to get a broad range of natural expressions. To overcome this problem, I try to engage my subjects in conversation during the photo shoot. I ask them about their friends, the foods they like, their favorite activities, and so on. Lately, I have taken to telling stories to younger children, including silly embellishments which they particularly enjoy. I have also found that talking about myself helps them to feel more comfortable.

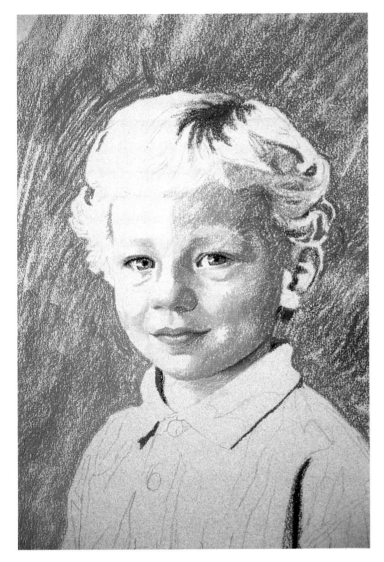

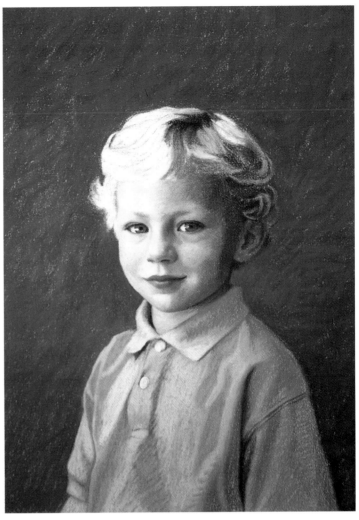

PLACING THE DARKS

In this close-up, you can see how I used deep raw umber and deep ochre on Peter's hair, and warm browns and cool violets on his face. I varied the pressure of my strokes to create a variety of values. I used a deep gray hard pastel sharpened to a point for the lash line and the cast shadow on the eyeball. Then I applied the additional dark notes to the corners of his eyes using a very deep red. For the iris I used a deep prussian blue.

OVERLAPPING COLOR

Next, I began to place cool violet and yellow ochre tones as my mid-tone transitions from darks to lights throughout the face — on the forehead, underneath the lower lip, to the left of the shadow on the nose, to the left of the nose where the muscle of his smile created a dark tone and in the shadows around the eye. I overlapped the colors wherever I wanted to soften edges, using the pastel sticks instead of my fingers to blend the colors. Then, using many shades of blue and aqua, I crosshatched layers of color in the shirt and background, working rapidly and using slightly heavier pressure.

"Notice how I used bolder, more intense colors to balance out the strength of the blues."

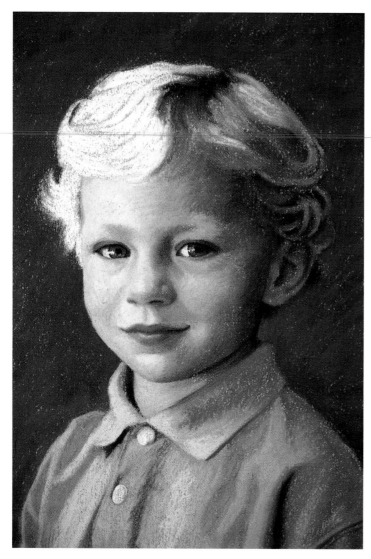

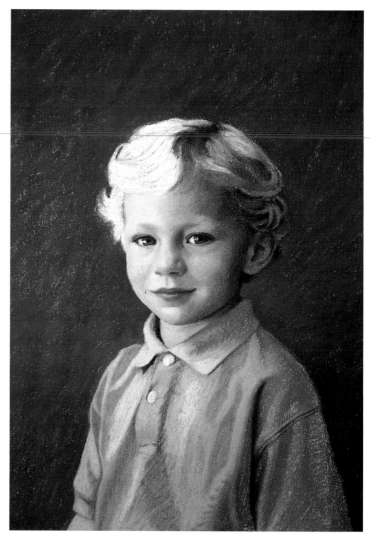

GIVING THE FACE MORE IMPACT

Wanting neither the background nor the shirt to be the strongest element in the portrait, I returned to the face to strengthen the shadow side and develop more dimension. Notice how I used bolder, more intense colors to balance the strength of the blues. I pressed more heavily than in my initial application while building additional layers of color.

ACHIEVING A PAINTERLY EFFECT

To complete the shirt, I placed the lighter values of blue on the collar and on the left side of his shirt. As I built up the layers, I crosshatched the strokes to achieve the painterly, textured effect I prefer, and which balances the softer effects of the skin tones.

To complete the hair, I layered more light shades of yellow ochre, some light raw umbers and a few pale greenish tones. Used in a crosshatched fashion, these colors simulated the undulating light and golden yellow tones of Peter's hair. As in many other parts of the portrait, I used the warmer, more yellow tones for the areas directly touched by the light and cooler tones in the areas that turn toward the shadows.

Borrowing from the Masters

By studying the work of both Degas and Cassatt, I learned to layer and crosshatch a multitude of colors rather than fill an area with a single hue. Even with bits of the surface peeking through, when viewed from a distance the colors optically combine into a beautiful, interwoven fabric of color — one of the most scintillating effects it is possible to achieve in pastel.

REFINING COLOR AND LIGHT

Once again, I went over the entire portrait, building additional layers from dark to middle tone to light. As I refined some of the features, I made sure I had modeled all the components with middle tones without any abrupt changes in value. For example, the shadow line down the center of his nose was quite clear to see, but I had to apply a middle tone to the front plane of the nose just to the left of the shadow in order to create a smooth transition from shadow to light. The same was true of the upper lip.

I then looked for opportunities to balance warms with cools, even in the background where I wove in more shades of blues and ochres. Then, being very conscious of the direction of light, I placed the lightest tones on the upper forehead and brow on the left, on his cheek on the left, on the tip of his nose and on the top edge of the upper lip. "Peter", 17 x 14" (44 x 36cm) was finished.

Bring out the gentle warmth of your sitter by surrounding the figure with harmonious colors.

BALANCING WITH TEMPERATURE
*This portrait of "Christian", 26 x 22"
(66 x 56cm) has a harmonious theme.
All of the colors in the clothing and
background are similar and balanced by the
colors of the figure's head and arms.
Also, I added lots of cool violet in the arms,
hands and face to further soften the
arrangement of color around her, making the
warm tones of her face and arms stand out.
This color scheme emphasizes Christian's
gentle, quiet character.*

Using harmonious color

Like many artists, I cringe when a client asks me to match the color scheme in a portrait with the room in which it will hang. To me, it is far more important to discover which colors will best enhance my sitters and, in a purely subjective way, express their personality.

In the demonstration portrait of Abby, an active, outgoing young lady who is one of my daughter's closest friends, I felt the sitter would be best portrayed by using a harmonious color scheme. By harmonious, I mean a pleasing arrangement of colors that work well together. For instance, analogous colors — two or three colors that are next to each other on the color wheel — often make a harmonious color scheme. In general, harmonious colors have a softening effect on the sitter.

Despite knowing what direction I wanted to take the color scheme in Abby's portrait, I began, as always, by applying my colors cautiously. In my first pass, I usually attempt to match the value and color in the photo reference as accurately as I can. Then, once I have placed more color throughout my composition, I become bolder in my color choices and strive to establish a balance of rich hues and gentler tones.

CENTERING ON YELLOW

Because all the colors in this portrait of "Sam and Alexandra",
30 x 40" (76 x 102cm) relate to yellow, it could be said to have
an analogous color scheme. Notice how some of the yellows lean in
a warm direction while others move toward a cooler cast.

SETTLING ON SIZE AND VIEW

I had intended to paint a head and shoulders portrait of Abby, but I eventually decided to paint a three-quarter figure, just under life size. The client gave me the flexibility to choose the option I preferred, so I decided to include her hands because I feel that portraits that include hands reveal more about the subject.

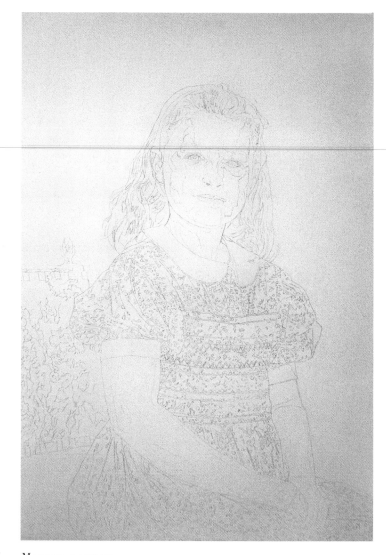

MAKING A START

I chose a 30 x 24" (76 x 61cm) pastel board with a slightly rough texture and prepared a detailed drawing on the surface.

A word of advice: Keep your color sketch to yourself

This demonstration illustrates the key reason why I hesitate to present a color sketch to the client in advance. Quite often, I feel the colors I develop in a small-scale version of the portrait are contrived and mainly based on the colors within my reference photos. But if I ask my client to approve the sketch, I am obligated to follow it. I no longer feel free to develop a more scintillating color scheme in the actual portrait, nor am I able to use color to solve problems as I did in Abby's portrait. Consequently, I much prefer working without preconceived ideas so that I can bring my experience and creativity to each new portrait as I paint it.

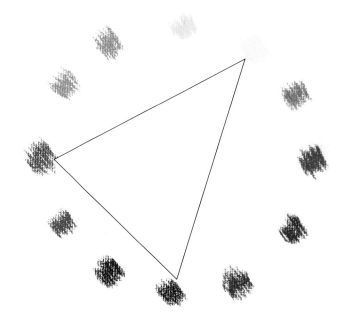

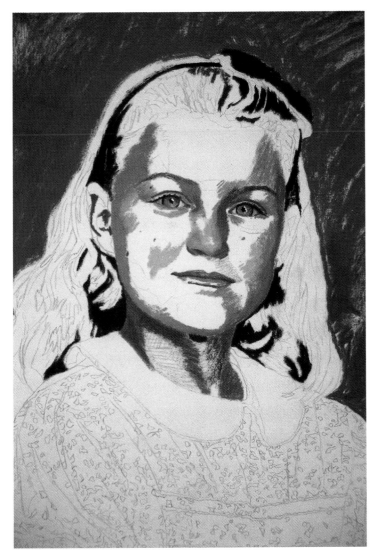

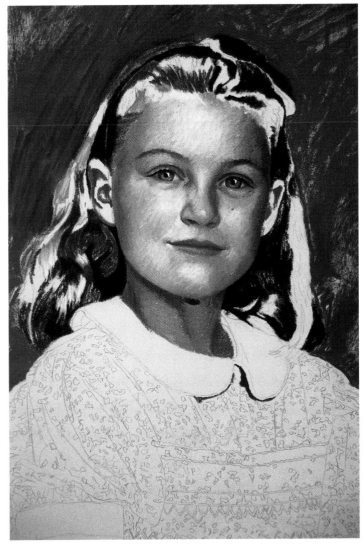

MASSING AND DEFINING DARKS

As I frequently do, I began with the darkest tones in the head, using the sides of the sticks to mass in some shadow areas in the face and neck. I used the points of other hard pastels for finer lines around the eyes. For the irises of Abby's beautiful light green eyes, I used a rich yellow-green. I then established the background around the head with a combination of deep ultramarine blue and deep cool grays.

DEVELOPING THE FACE

I placed yellow ochres, umbers, siennas and pale shades of orange in the light areas of the face and hair. I intentionally overemphasized the planes of Abby's head to bring out the effect of light falling on a three-dimensional object, knowing that I could later adjust and balance the values as I saw fit. To check the results of my work, I stepped back to observe the values from a distance, then I looked at them in a hand-held mirror for an even more distant, objective view.

"By harmonious, I mean a pleasing arrangement of colors that work together, and that have a softening effect on the sitter."

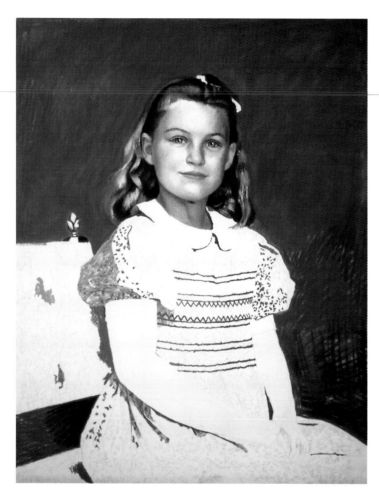

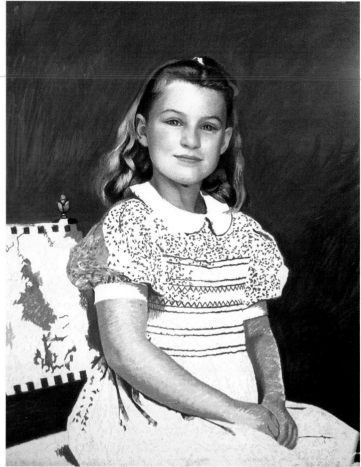

BEGINNING TO HARMONIZE COLOR

Finishing her hair with more yellow ochres gave me a bit more confidence in my color choices for the face but I was still unsure, so I decided to turn my attention to the background, clothing and chair. I wanted these areas to harmonize with the warm skin tones, so I repeated variations of blue in all areas surrounding the head, including the dark blue smocking on the dress.

SOLVING PROBLEMS WITH COLOR

As soon as I began to put more color in the background, I realized I still was not satisfied with the head. I opted to scratch out much of it with a single-edged razorblade and start again. In my second attempt, I placed violets and ochres that were more accurate in terms of value.

The difficulties of working with people you know

Painting someone you know quite well can have its advantages and its disadvantages. I am sure one reason I had such a hard time with this portrait is that I know Abby so well. Because I know so many sides of her character, it became more difficult to encapsulate my vision of her in a satisfactory way. On the other hand, once I had overcome my uncertainty, and struggled through the difficult circumstances, I was very pleased with the results.

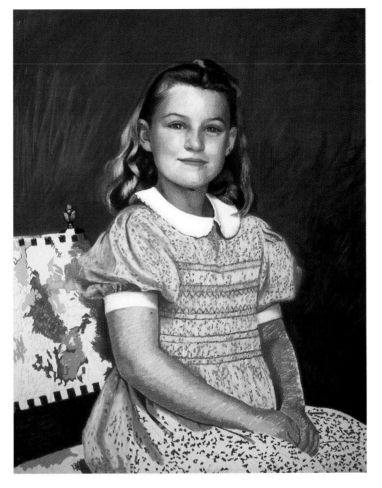

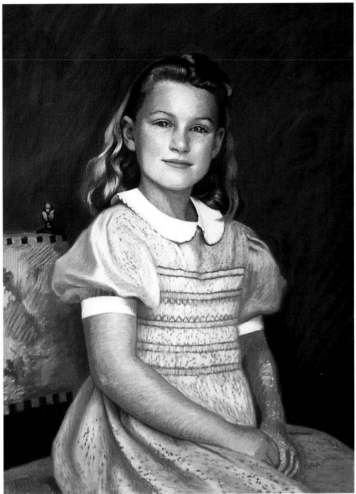

MOVING ON TO THE DRESS

I spent an inordinate amount of time struggling to develop the head satisfactorily. But finally, I could redirect my attention to Abby's dress. With its tiny pattern, I was uncertain how to begin — should I tackle the form of the dress first or emphasize the pattern? I decided to model the dress before working in the small, dark, floral pattern.

ADVANCING THE SUPPORTING AREAS

Next, I continued developing the chair. As you can see, I was pressing rather firmly as I applied strokes of color throughout the dress, chair and background. I did this so I could rapidly bring the rest of the painting up to the same degree of development as the reworked face. Until I had all parts of the portrait at the same level, I could not evaluate what else needed to be done.

After studying the value relationships more carefully, I pushed more of the chair into shadow using the blue/gray tones of the background. I also covered most of the dress with a light cerulean blue, then created more dimension by strengthening the shadows and pulling out the lights, even in the "white" collar and sleeve. The majority of the colors I used were in an analogous or harmonious direction with the exception being in her head and arms.

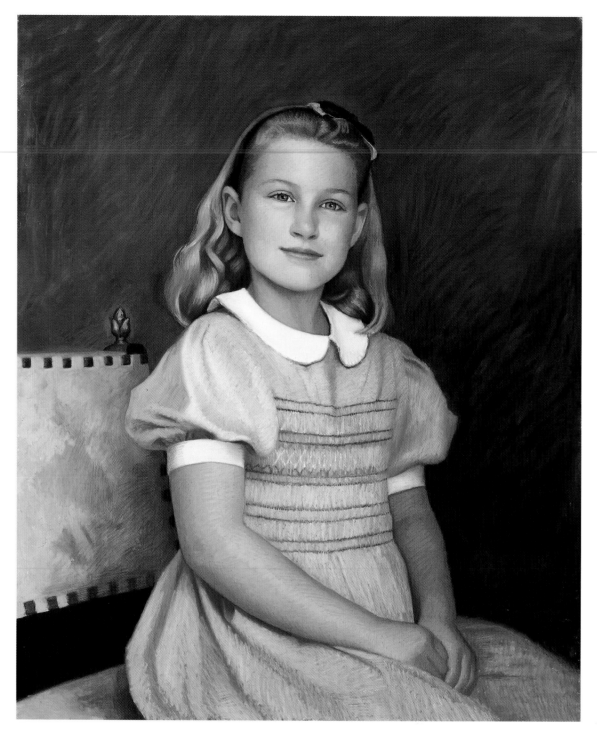

REFINING THE COLOR

By this time, Abby's head no longer appeared as problematic as I had originally thought. I further harmonized the color scheme by adding some deep sap green, indigo and prussian blue to the shadows in her hair.

By layering on more warm tones in her hair and skin, I fused and softened some edges and defined other crisp edges. I also re-established some planes with more brilliant colors to balance the bright colors throughout the background. Notice how I left visible strokes of color in her arms and dress for a more painterly effect in these areas of "Abby", 30 x 24" (76 x 61cm).

"By layering on more warm tones in her hair and skin, I fused and softened some edges and defined other crisp edges."

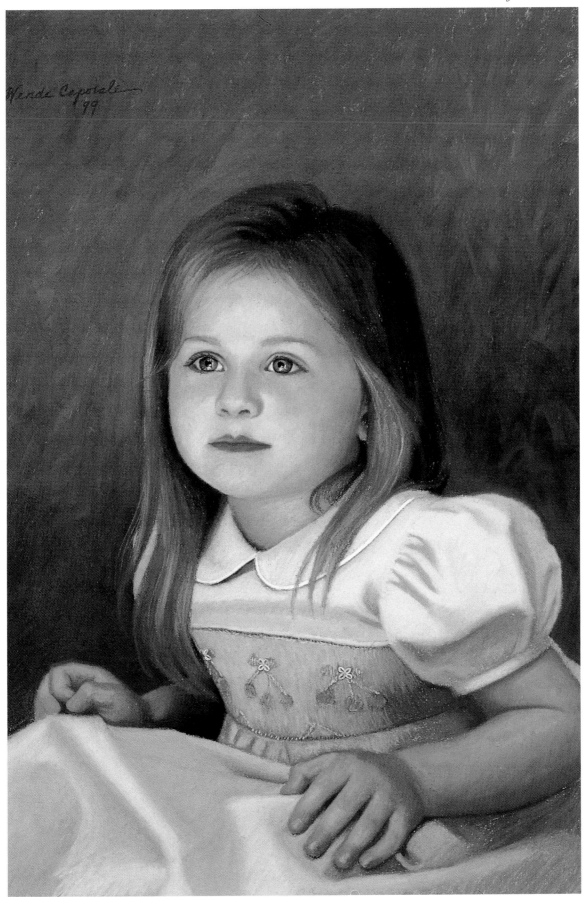

HEIGHTENING YOUTH AND INNOCENCE
*In this portrait of "Tess", 20 x 16" (51 x 41cm), I harmonized the cool colors
surrounding the model with warmer tones in her face and arms. This
combination of colors enhances this young model and emphasizes her innocence.*

Take advantage of the vibrant contrast of complementary colors to add richness and vitality to a portrait.

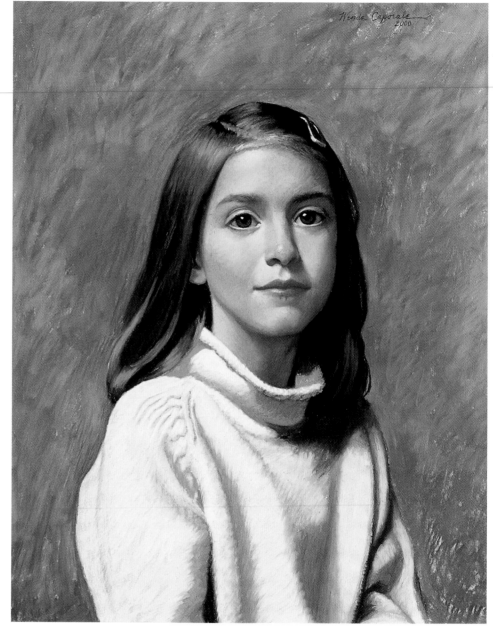

TAKING MY CUE FROM THE
SITTER'S COLORING
When I first met "Paige", 20 x 16"
(51 x 41cm), I was immediately
enthralled by her striking dark hair
and eyes as well as her gentle demeanor.
The way her dark hair framed her face
gave me the chance to develop a rich
variety of violet tones in the background
to complement her yellow sweater.
I particularly enjoyed the effect of
Rembrandt lighting here, which defines
her lovely features.

Using complementary color

Although I frequently know what general color scheme to use for a new portrait, I just as often start without a preconceived idea of my color scheme and let it evolve. Even though I work from color photographic references, I do not limit myself to the colors shown in them. There are many color options and I remain open to the possibilities as I work.

In general, I begin by intuitively placing bits of color suggested by my references and essentially I try to balance them in one way or another. I have no concrete formula for arriving at a certain theme, but rather allow my sense of color to guide me. For example, in the demonstration portrait of Louise, I intuitively used indigo and purple to create a dark, exciting background. Some violets in her face created shadowed areas. But as I developed the rich yellows in her hair and dress, it became obvious that emphasizing the complement of yellow — purple — would introduce an extra level of vivacity to her portrait.

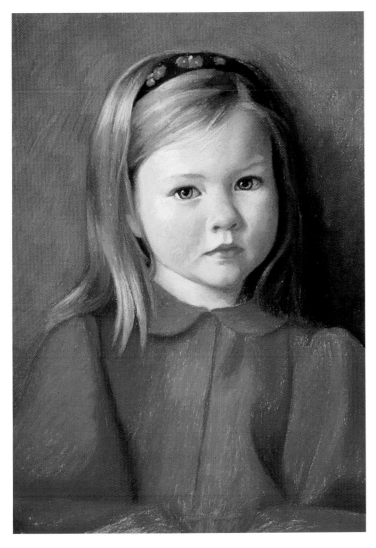

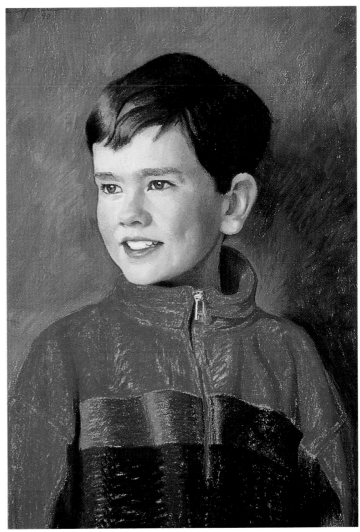

KEEPING IT IN THE FAMILY

Because this portrait of "Chloe", 16 x 14" (41 x 35.5cm) was to be a companion to the one I had previously painted of "John" at right, I used the same blue-green background. I especially liked the way the cool tone contrasted sharply against the warmth of her dress, which enhanced her skin tones.

BORROWING FROM A MASTER

In this portrait of "John", 16 x 14" (41 x 36cm), I was able to use a particularly vibrant red sweater against a blue-green background to enhance his handsome, dark features. In my preparation stage, I recalled seeing a background color like this one in a portrait by Hans Holbein, and I felt that this rich color would beautifully offset John's skin tones.

Turning point

A master class workshop I once attended gave me some very useful insights. The instructor, respected portraitist Nelson Shanks, suggested applying the most obvious colors in the composition first, since they are more easily seen and recognized. This immediately made sense to me. Developing the more obvious colors early on creates a framework for the painting and allows the artist time to discern the more elusive colors before too much other work has been done.

ORIGINAL PHOTOGRAPHIC REFERENCE

GETTING RIGHT TO THE DARKS

I began by scaling up the sketch made from my original photograph and transferring it to my sanded board, positioning the figure in a way that fully utilized the scale and proportion of my surface. Using a pencil, I drew the main contour lines of the shapes of the shadows, including some detail. I then began massing in the darks — raw umbers, blue-grays and deep greenish-grays in the background area; raw umbers and deep ochres in the hair, and deep violets in the shadows of her face and beneath her chin.

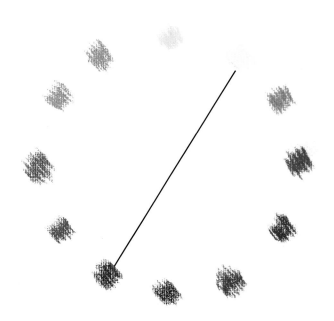

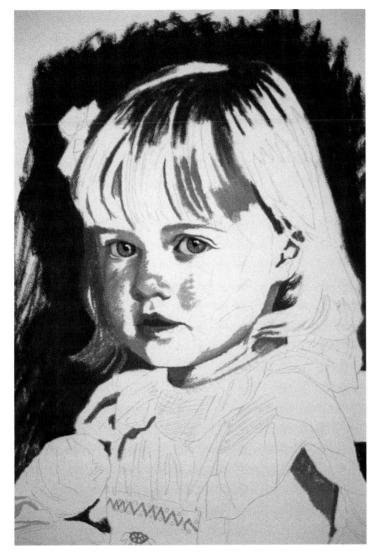

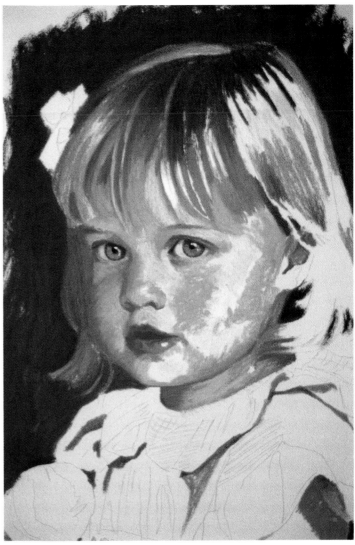

ESTABLISHING THE VALUE RANGE (DETAIL)

To suggest the shadow cast by the eyelid, I applied the same background blue heavily on the top of the iris and more lightly on the remainder of the iris. To suggest deeper colors in the other shadowed parts of the face, I began with a hard pastel in a warm brown and later integrated softer pastels in deep violet-red and violets. Contrasted against the light tone of the surface, these darks established my range of values and began to suggest form and volume.

BUILDING THE CENTER OF ATTENTION (DETAIL)

As I continued, I realized that the head in the 8 x 10" (20 x 25cm) photo, being approximately 2½" (6cm) high, did not provide sufficient information, so I had an 8 x 10" (20 x 25cm) blow-up of the head made. Following this more detailed reference, I continued to develop the center of attention, Louise's face, by putting in the mid-tones, always remaining aware of the direction of the light source and its effect on my modeling of the figure. I applied the various warm and cool colors in small, crosshatched strokes with a light touch to prevent the board's tooth from filling too soon.

"To draw the viewer's eye to the face, the focal point, I made sure I placed my highest and brightest colors against the dark background."

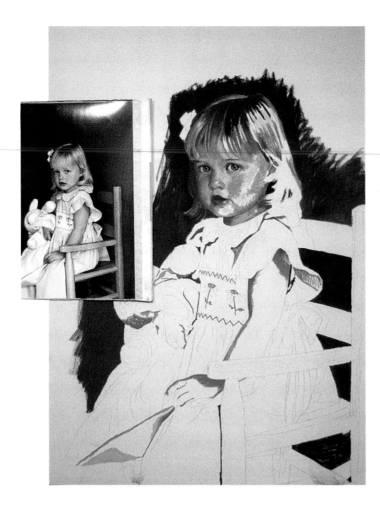

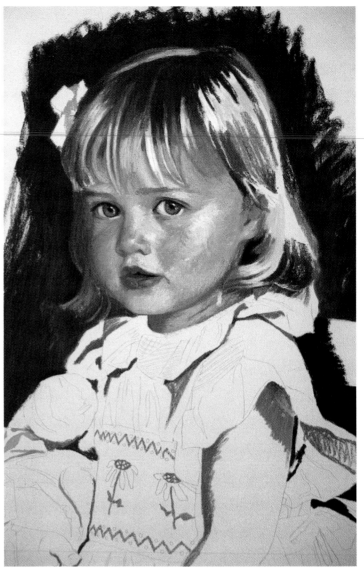

REPEATING COLORS

Although I was focused on the head, I quickly realized that the same colors could also be applied elsewhere in the painting. Note, for example, how I used some of the violet and ochre from her hair and face in her dress, which helped to unify the colors. At this stage I allowed the light middle value of the surface to represent the value of Louise's dress, blanket and stuffed toy.

EMPHASIZING THE FOCAL POINT (DETAIL)

I returned to her face to finish putting in my range of values. By working back and forth between this isolated area and the painting as a whole, I made sure I placed my lightest and brightest colors on the head to draw the viewer's eye to the face.

Checking a work-in-progress

Throughout the painting process, I view my work and my subject simultaneously through a hand mirror. I do this whether I am working from a photo or a model. The mirror provides a more objective perspective from which to check my progress. Another way to observe a portrait objectively, although it is not as readily available, is to see it in print form. Either of these methods are excellent for checking the value relationships, color and drawing accuracy of a work-in-progress.

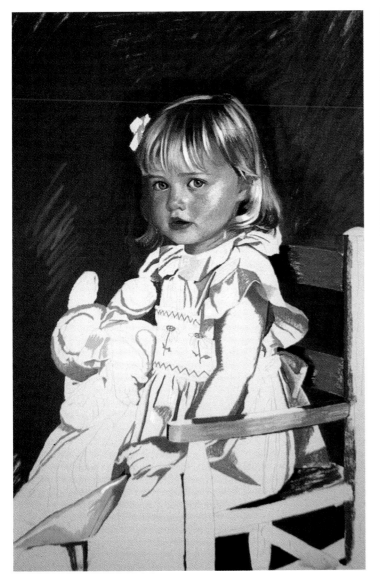

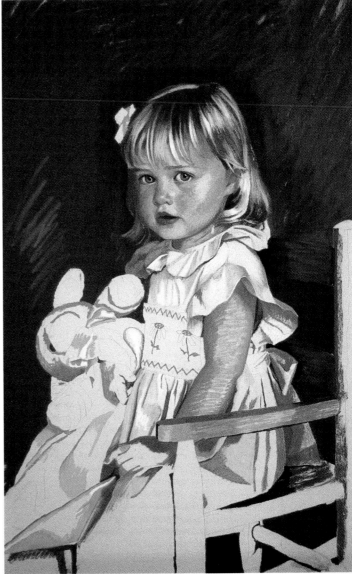

HARMONIZING THE MIDDLE TONES

Next, I developed the mid-tones in her hair using a range of deep ochres. I applied these same colors to the shadowed areas on her dress, again to tie the figure to the dress. Establishing the middle tones prompted me to finish the deep gray background around her figure and the chair, using the correct degree of value contrast.

EXPLORING COLOR OPTIONS

Unsure of which colors to use in her dress, I decided to begin with yellow ochres in the correct values, since I had already used this color for the shadows of the dress. I lightly ran broad strokes of these colors over the entire surface of the dress. But as I became more acquainted with this area, I suspected there were better, more successful colors and values to be used for the middle tones and lights. After a thorough search of my pastels, I found, to my delight, a variety of greenish-yellows that would achieve the color I wanted when layered over the ochres.

"I had intuitively used indigo and purple to create a dark, yet exciting, background as well as some violets in her face to create shadowed areas."

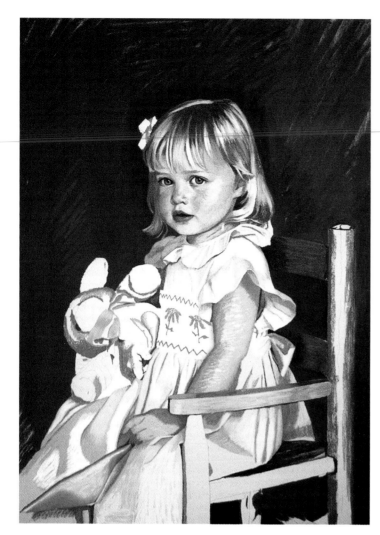

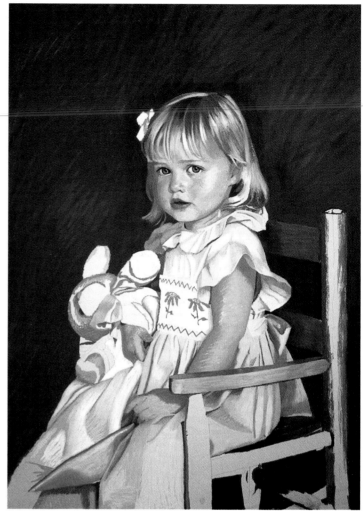

MANIPULATING COMPLEMENTS

At this point, it occurred to me that the deep ochres and greenish-yellows offered a visually pleasing contrast to the violet notes in the background and the head. I decided I should accentuate this pair of complements to create a strong color relationship in the painting. To step up the interplay of the rich complements, I placed warm yellowish flesh tones on her arms, and introduced some violet-grays and blue-violets in her blanket and toy. Then I intensified the violet tones in the background. I left the lower half of the background in cooler tones of blue-gray because that area was in shadow.

EXAMINING EDGES

To complete my initial pass of color, I completed her precious toy and blanket as well as the hand holding them using lighter tones. Then I pushed back some areas with deeper darks. With this stage complete, I addressed the edges where different values came together. I realized that the edge of Louise's face on the left meets her hair in shadow, so I decided to "lose", or soften, the left edge of her cheek into the shadow next to the hair. I also softened the edges of the jaw line as it turned under her chin. However, I allowed the shadow on her nose and around her eyes to remain sharper to bring them forward and to draw attention to the center of her face.

Painting a family of portraits

Parents with several children often request individual portraits of each child. In this case, I was commissioned to paint portraits of Louise's two brothers as well. When I receive this type of commission, I always consider how the group of portraits will look when hung together in one location, as they probably will be. Although I used the same three-quarter figure view for each of the three portraits, I did not think it necessary to make each portrait identical. A portrait should reflect the personality of the individual in its own way. So I chose to show Louise indoors because it suits her demeanor, while her two brothers were shown outdoors, which is where they are often found.

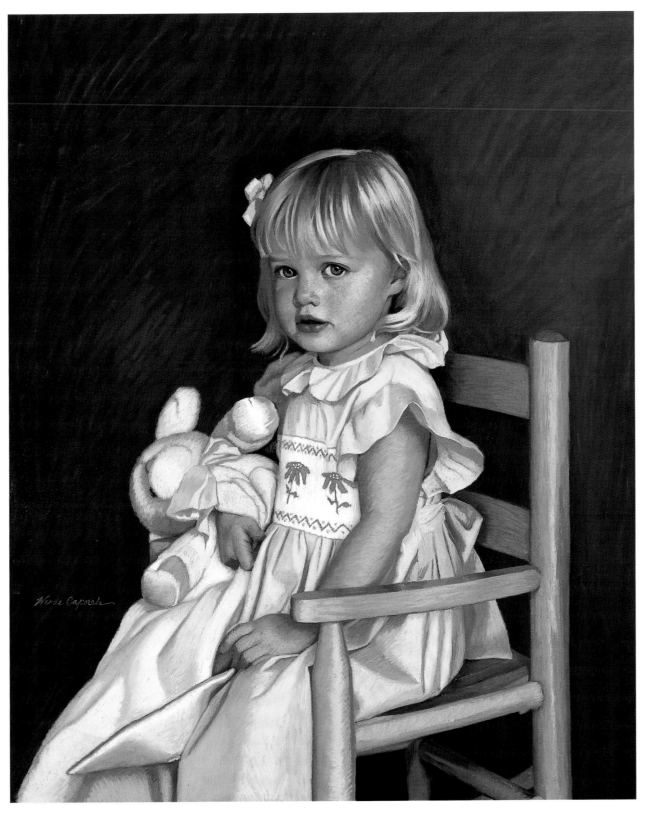

REFINING STROKE BY STROKE

*To complete the chair, I added the middle tones, then followed
with some lighter values. Only a few final refinements in the
details remained, which meant holding my breath at each stroke
of warm or cool color. With each additional stroke, I questioned
whether to render precisely or to allow the beauty of the textural effect
of the pastel to be evident. As a result, I obtained a balance of some
smooth passages and other softly crosshatched or textured ones, which
add interest and depth to "Louise", 30 x 24" (76 x 61cm).*

Placing your model in an outdoor setting not only creates a sense of mood and environment, it brings an exciting level of variety to your work.

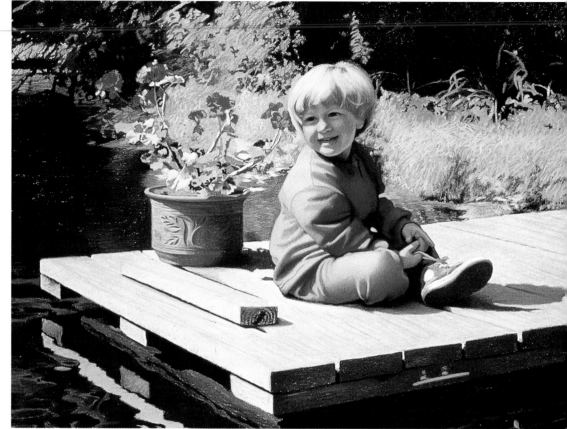

USING CONTRAST TO BRING OUT THE WARMTH

I had to shoot my reference photos for "Aaron", 30 x 40" (76 x 102cm) from a boat in order to capture my model on the dock from the angle I wanted. The sun-drenched atmosphere of the late summer day permeated everything with a warm light and reinforced the orange tones in Aaron's face. To enhance and enrich these orange notes, I used a lot of blue — the complement of orange — in the background.

Including atmospheric light and color

The right background environment for a portrait can say so much about a person. With portraits of children in particular, an outdoor setting can reveal something about the child's home and personal interests. Used effectively, an outside environment can also set a wonderful mood.

Of course, you want your young sitter to look natural in the location. This requires close attention to the effects of natural light and the atmospheric colors that permeate and unite the subject with the setting.

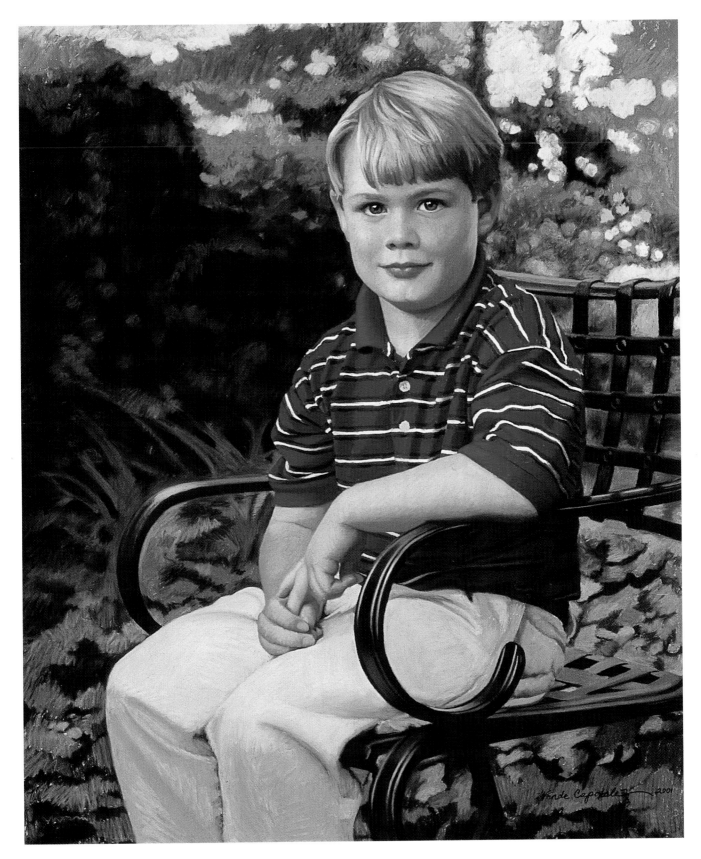

CREATING COMPANION PAINTINGS—NOT COPIES

"Reed". 30 x 24" (76 x 61cm) is the brother of Scott, the subject of the
main demonstration. This was handled in much the same way as the
demonstration in this chapter. However, although I photographed him in
a similar setting, I took the photos at a different time of day. This allowed
me to create two compatible paintings with unique and distinctive
characteristics. Notice how cool light reflects onto the shadowed side of
Reed's face and beautifully contrasts with the warm yellow behind his head.

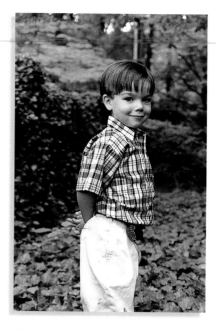

ORIGINAL PHOTOGRAPHIC REFERENCE

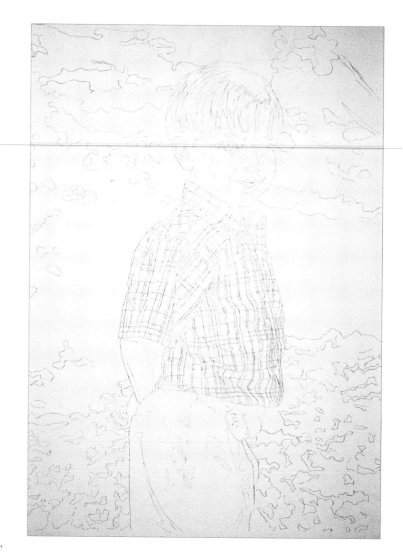

DRAWING UP A PLAN

I chose a mid-tone gray board, and used an HB charcoal pencil to draw Scott's figure and indicate some of the background and shadow shapes behind him. The benefit of working on a mid-tone surface rather than on a white surface is that darks and lights register immediately when they are placed on the board, making it easier to gauge the accuracy of the values.

Escaping the trap of dull color

One of the problems of working from photographs is that it is so easy to fall into the trap of limiting yourself to the colors found there. Unfortunately, photographs cannot capture the brilliant colors of life, so copying the colors in a photograph can lead to a dull, almost monochromatic color scheme. To avoid this trap, I recommend a two-step process. First, work from life as often as possible to familiarize yourself with the true colors of nature. Then, rely on this experience to use brighter, more saturated colors when you do paint from photographs and you will ensure a more life-like appearance.

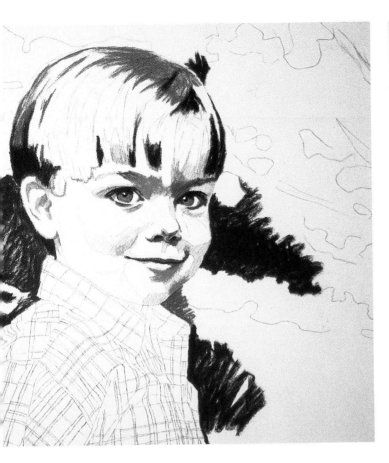

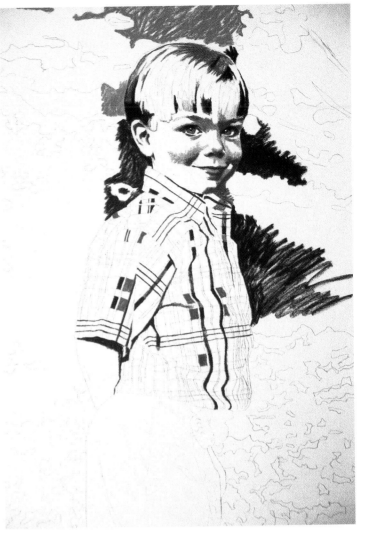

BALANCING WARM AND COOL DARKS

I began applying the dark areas in and around Scott's head. I used primarily cool umbers in the hair and violets for the face, as well as deep viridian and indigo in the background. These cool colors would offset and complement the warm tones to be applied in the face. I painted the irises of his eyes with a deep greenish-brown, the upper and lower lash line with a deep warm gray hard pastel, and the upper lip, corners of the mouth, nostrils and corner of the eyes with combinations of warm violet and alizarin. I made an immediate statement with these darks by applying them heavily.

CREATING SCOTT'S ENVIRONMENT

Moving upward and to the right of the figure, I placed more cool blue-green tones in the background. As I continued to develop the portrait, I looked for opportunities to repeat the blue-greens in the figure so Scott would appear to be part of the environment instead of looking as if he had been pasted onto it. For example, notice how I used some of these same cool tones in his shirt in the background as well.

DETAIL

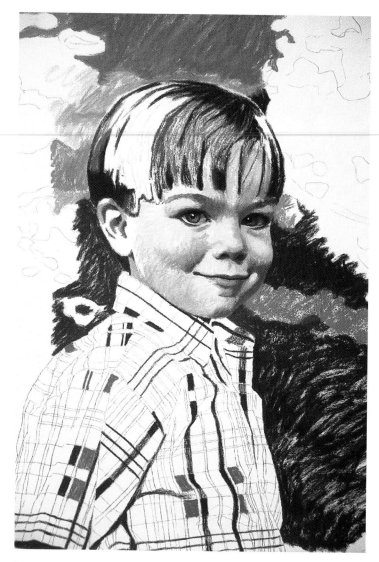

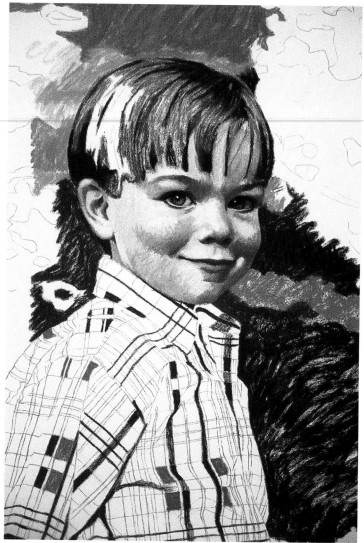

TURNING DARK INTO LIGHT

Working from right to left, I applied more mid-tone colors — such as raw sienna and violets — throughout the face and hair. I used a light touch so I could continue layering additional colors in a "woven" pattern. At first, my color choices seemed overly bright, but I knew that if I continued to use rich, saturated color all over the painting, their appearance would be neutralized and balanced.

SHOWING HOW LIGHT FALLS

To complete the initial layer of pastel over Scott's head, I used a combination of pale orange, ochres and pinks in a similar value to represent the lightest tones. I then prepared the ear with deep violets and deep red tones. Paying attention to the planes of the head and their angle to the light helped me determine not only what value to use, but also what the color and temperature should be. I then used my darkest red for the corners of the eyes, the nostrils and the division between the lips. This is a "life-giving" approach learned from studying the works of English painters Sir Thomas Lawrence and George Romney.

"I made an immediate statement with the first darks by applying them heavily."

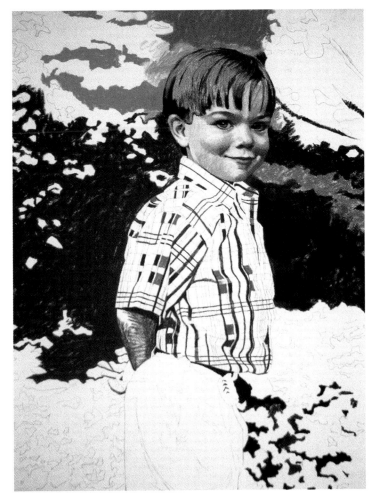

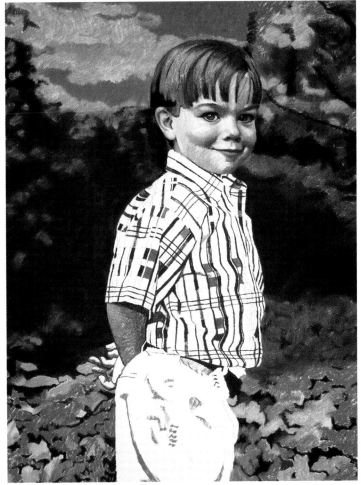

DEVELOPING THE BACKGROUND

Once I had added some golden ochre tones and burnt umber to improve the modeling in the head, I needed to develop the surrounding areas. I used the same colors to render the arm and hand, but added a few slightly cooler tones to show how the foliage was reflecting cool color onto his skin. I then began to paint the background in an abstract way, juxtaposing shapes and simplifying colors. I varied the colors throughout by using a full range of greens in broken, painterly strokes so the background wouldn't overwhelm the figure.

TURNING TO THE CLOTHING

After covering the background, I worked more on the hand, constantly checking and revising my drawing as I proceeded. Since the clothing is such a strong element in this portrait, I next began to lay in the shadows in the shirt and pants, using some of the same blue-greens I had used in the background for unity.

DETAIL

DETAIL

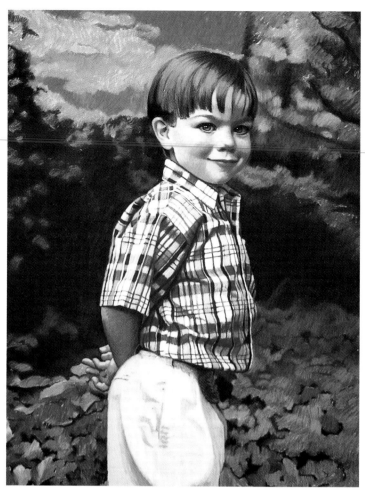

PAINTING PATTERN AND FORM

I simultaneously put in the shirt pattern and created the form with indigo and deep grays for the shadows and lighter values as I worked toward the light. I completed the pants with raw umbers and greenish grays, moving toward yellowish-green for the lightest areas.

PUSHING BACK THE BACKGROUND

When I had finally covered all areas of the painting, I stopped to evaluate it as a whole. I softened many of the edges and brought all of the values closer to each other to make the background recede and create more of a contrast for the figure. I added more layers of colors and values to the face, sharpening some edges and softening others.

Focus on relationships

Painting a portrait, or any subject for that matter, is not about painting the individual elements in the scene. Painting is about creating a cohesive picture, where all the elements are related to each other. This is why it is so important to block in the entire surface first, being as accurate with your values and colors as you can, before going back to refine any one area. Once you can see the painting as a whole, you can more easily adjust the overall value pattern, enhance colors where needed and define the center of attention.

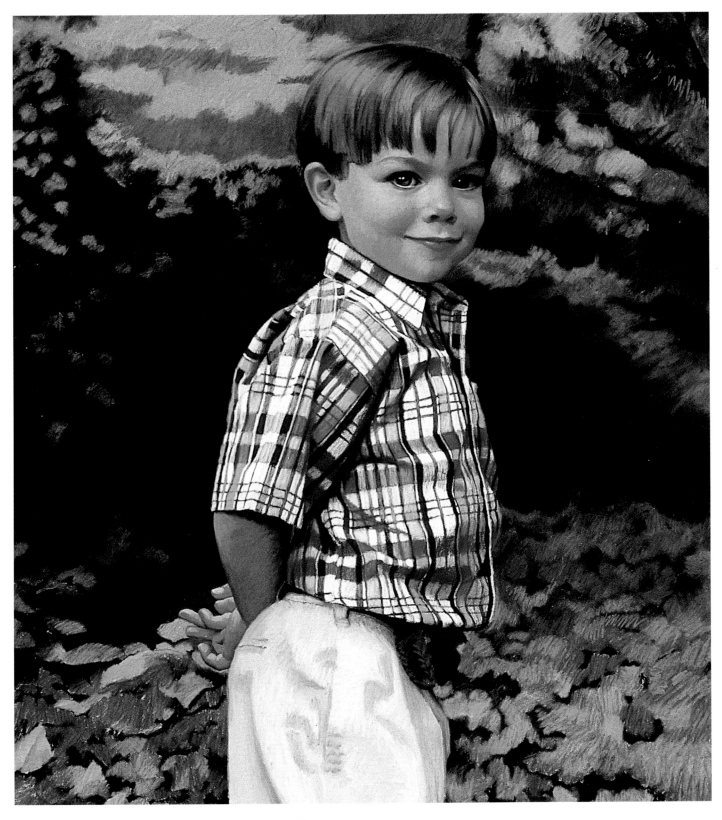

ENHANCING DIMENSION

*In the final sitting, I positioned Scott under similar natural lighting
conditions. I decided to enhance the illusion of depth in the painting by
strengthening the darks and lightening the lights. Using different degrees of
pressure to vary the values generated by the same few pastel sticks, I added
deeper tones to the background and throughout the clothing and face. I also
thought the hair could be developed in a more interesting way, so I added a
series of warm browns, which have a pale pink hue in the lights. A few final
highlights completed "Scott", 30 x 24" (76 x 61cm).*

Personalize and
enrich a child's
portrait by
including a
beloved pet.

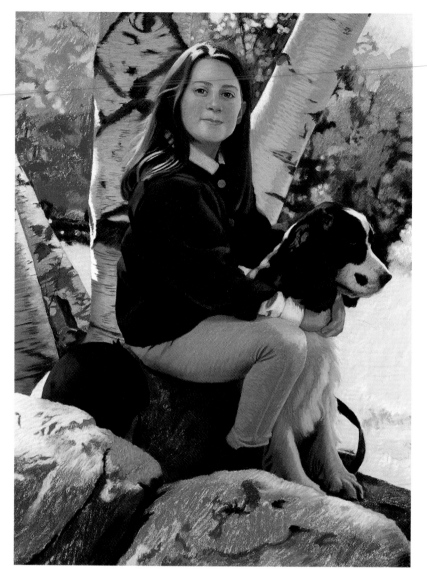

"AVIGNON AND VELVET", 36 x 29" (92 x 74cm)

Including a pet

Including a pet in a portrait is a wonderful way to tell viewers something more about the child's interests and personality. Although including a pet increases the difficulty of the portrait, it also commemorates that time in the child's life.

For the demonstration starting on page 78, I chose to paint my daughter Avignon and one of her dogs in an outdoor setting near our home. Avignon is quite an athlete and participates in many sports but particularly enjoys riding horses. To my delight, she agreed to pose in her riding outfit as opposed to her soccer or softball uniform! Velvet is the first dog Avignon

raised from puppyhood, so I thought it would be particularly fitting to include her in the portrait.

Because I have been painting more landscapes in recent years, I have also been inspired to develop interesting outdoor backgrounds for some of my portraits. For Avignon's portrait, I thought the black and white colors of the dog's coat would tie-in beautifully with the birch trees, making a strong graphic statement against the bright colors of the fall leaves. As you will see, the result was essentially a study in grays, backlit with brilliant color and light.

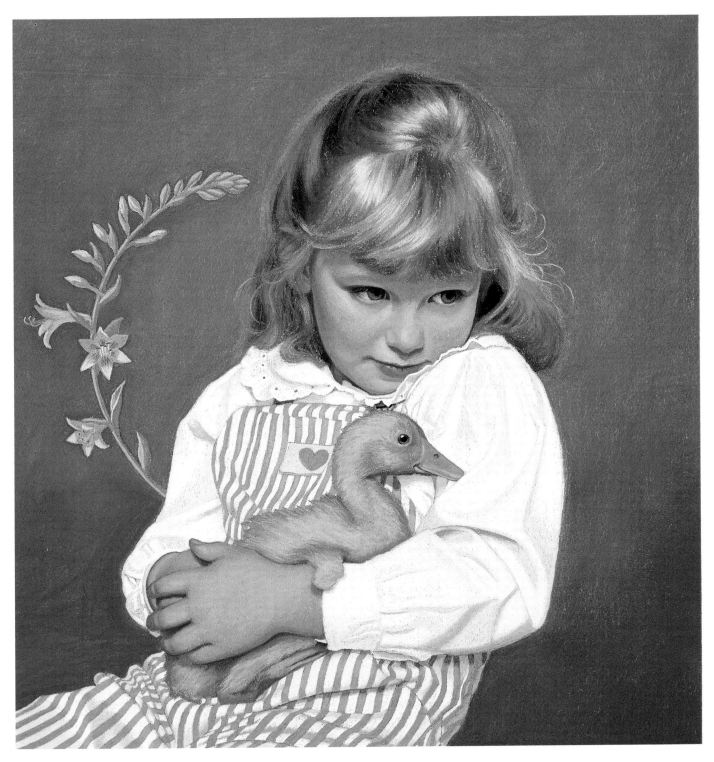

WORKING WITH PETS TAKES PATIENCE
*For "Kit with Duck", 14 x 14" (36 x 36cm),
I had to pose my young model with the duck.
Needless to say, I used loads of film to get
just the right position for both the girl and
the animal. In this situation, lots of patience
and plenty of time are required.*

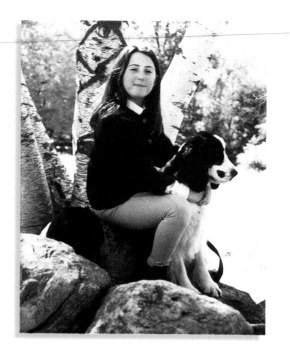

ORIGINAL PHOTOGRAPHIC REFERENCE

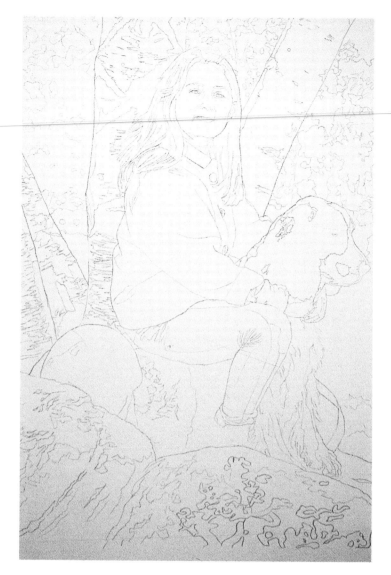

MAKING A DETAILED DRAWING
Choosing a large, gray sanded board in the same proportions as my reference photo, I began by making a detailed drawing.

"I concluded that I should also place some of the more obvious, easily recognizable colors around my subject. I knew this would encourage me to use stronger colors when I began to develop the head."

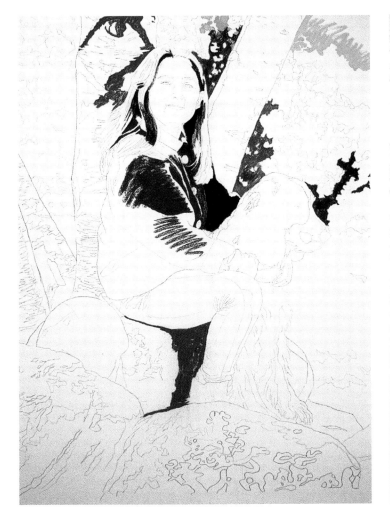

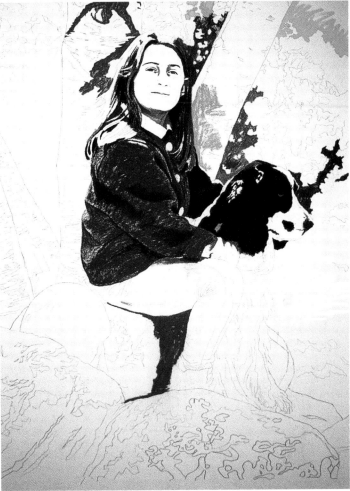

MAPPING OUT THE MASSES

I instinctively began by preparing the darks in the hair. When studying the flat lighting and minimal color in Avignon's face in my reference photo, however, I concluded that I should also place some of the more obvious, easily recognizable colors around my subject. I knew this would encourage me to use stronger colors when I began to develop the head.

PLACING RICH COLOR

Continuing in this vein, I began to lay in some of the cool gray abstract shapes in the birch trees behind her head, as well as the broad area of bright greens to the right in the background.

Holding off on black

Even when I am painting a very dark subject, such as Avignon's black jacket or her dog, I rarely use black in the initial layers. This is because black does not fill the tooth sufficiently so it provides very poor coverage, and also because I want to save my deepest darks and lightest lights for the end of the painting, when I want to enhance the feeling of depth and dimension.

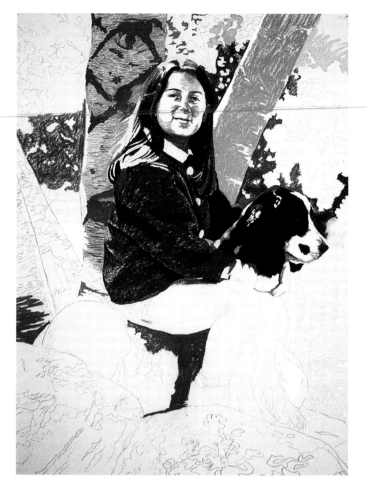

Working with Value

I used two values of blue to paint her jacket, and gray-black for the dark shapes of the dog. Notice how I pressed more heavily on the pastel in the dark areas and eased up along the outer edges of these shapes to register the effect of backlighting from the warm sun. Using the value of her hair as a key, I then placed the deep shadows around her face.

Moving into the Background

After developing the birch trees in shadow, I began on the abstract shapes of color in the trees and sky behind the figures, massing in broad patterns of light and shadow. While I did this I continually compared the values. I used combinations of blues, yellow-greens and varying shades of orange and red. Next, I prepared the riding pants with a deep raw umber in the shadows on her leg. Even though it was early in the painting, I was aware of the edge of her sleeve against her leg and thought carefully how to portray this area with the proper contrast of edges.

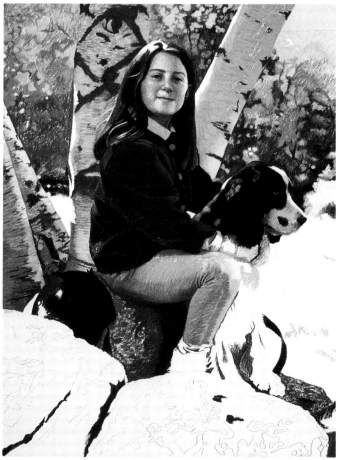

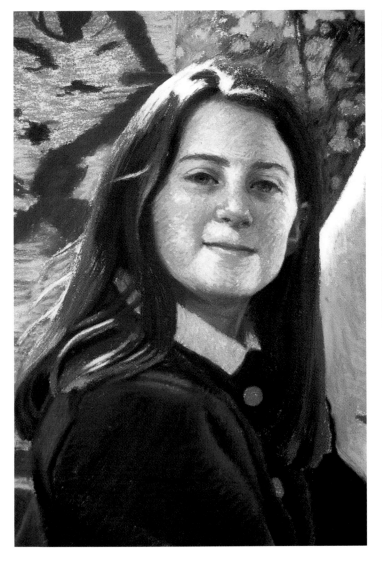

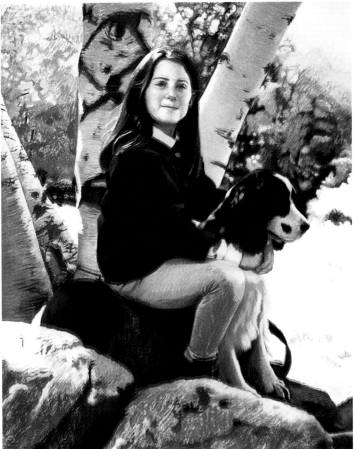

FINISHING THE FOREGROUND

Using a variety of grays integrated with some greens, blues and violets to suggest atmosphere, I covered the rocks in the foreground, which were also primarily in shadow. As I was doing this, I gave some thought to the texture of these elements and applied the pastel in a way that suggested their tactile qualities. Of course, as I found colors that tied into the figures, I repeated them wherever it seemed appropriate.

MODELING THE FACE (DETAIL)

In this close-up, you can see how I began to render her face, which is almost entirely in shadow except for the light on her hair. The rich colors ranged from cool violets, deep ochres and greenish-grays in the shadows to cadmium red light, pale raw umber and yellow ochre in the mid-tones. On the right side of her face, I reflected the yellow-green from the grassy area.

"I gave some thought to the texture of the elements and applied pastel in a way that suggested their tactile qualities."

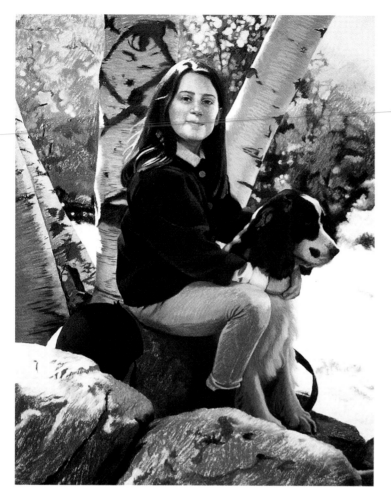

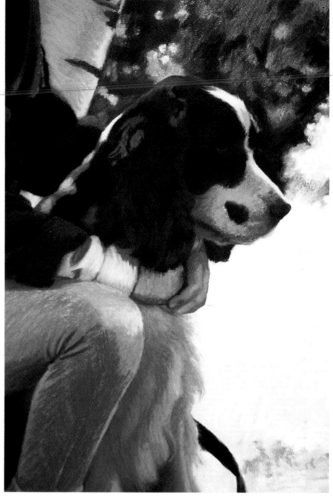

TONING DOWN THE SETTING

Once the surface was entirely covered, it became easier to see any adjustments that were needed. In reviewing my painting, I was concerned that the bright colors and abstract shapes of the background were dominating the composition, taking attention away from my subjects. I decided to soften several crisper edges, simplify some of the abstract shapes and minimize a few of the stronger value contrasts in the surroundings. To accomplish this, I went over some of the trees and rocks with a lighter value of blue-green and a deeper red-orange.

Because Avignon was squinting in the reference photo, I decided to complete her face by working from life. I posed her in the studio under artificial backlighting conditions and positioned a large board to her right to recreate the reflected light on that side of her face. In this manner, I was able to get the information to refine the shapes within her head, open up her eyes slightly and clarify the colors of her face.

COMPLETING THE PET PORTRAIT

I layered on more colors to further refine the dimensional qualities of Avignon's hands, as well as the dog's head and body. Additional strokes of dark blue-grays and violet-grays captured the sheen in the dark areas of the dog's coat.

When is a painting finished?

In my last review of a painting, I run through a brief checklist of key questions that help me identify any final adjustments that may be required:

- Is the drawing of the figures and other elements accurate?
- Is there a balanced, pleasing pattern of values throughout the painting?
- Have I put the highest contrast of values in and around the center of attention?
- Are the effects of the light source accurate?
- Are the reflected lights represented in a subtle, yet visible, way?
- Have I used crisp edges in and around the center of attention, and have I created softer edges elsewhere?
- Is every area in this painting resolved to the best of my ability, or have I taken shortcuts that compromise the integrity of my work?

The moment of truth arrives when I feel these points are covered to my satisfaction and I am ready to sign my painting.

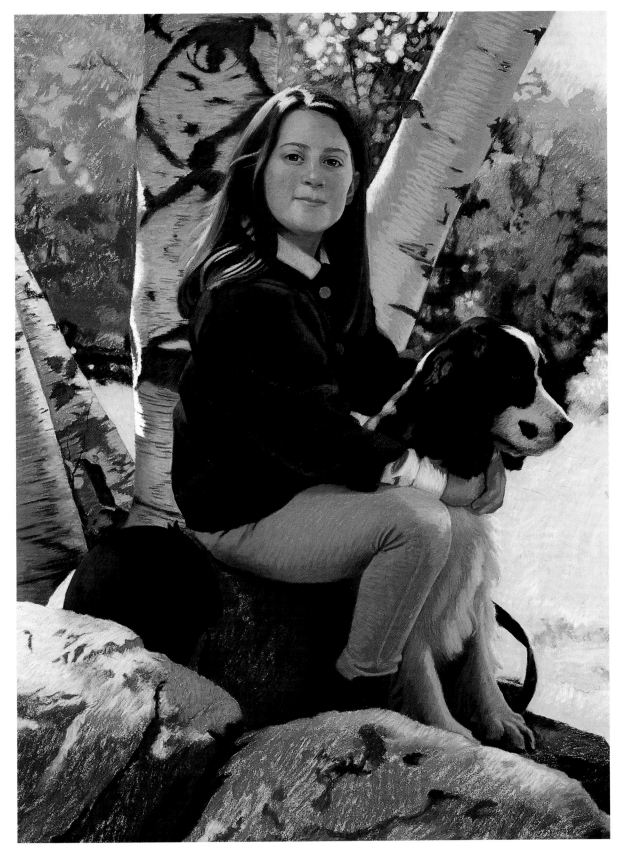

COMPLETING THE WORK

*When I was completely satisfied that the two figures had
the correct amount of modeling and detail, and that the
background provided a subtle setting for them, I was ready
to sign "Avignon and Velvet", 36 x 29" (92 x 74cm).*

You'll find that painting a series of self-portraits will develop your skills of analysis and make you much more sympathetic to your sitters.

MODELING FOR MYSELF
Inspired after a workshop I'd taken, and to continue working with the different palettes and unusual lighting situations we had studied, I painted "Self-Portrait", 20 x 16" (51 x 41cm).
I set up my easel in a small space in our barn. To mark my place between painting sessions, I placed small pieces of masking tape at the exact positions of my feet, the two easels and the light stand.

Including yourself in the portrait

Painting a series of self-portraits is an activity I highly recommend. Not only does this give you a chance to create something entirely to your own liking, it also allows you to experiment with new ideas and techniques. As a benefit, you end up with portfolio pieces that allow viewers to see how you, the artist, portray yourself.

Some years ago, I decided to include myself in a portrait of my daughter Avignon who was four years old at the time. This seemed a fitting representation of me as a mother and an artist. Painting myself with Avignon also felt natural because she has clearly shaped me as a person. Her fascination and curiosity about life single-handedly drew me into her world

and led me to experience familiar things in a unique way.

When designing the portrait, I decided it should be a full-length seated portrait set in our living room, which also serves as my studio. The dark green leather chair and rough greenish-beige stone on the fireplace complemented our softer reddish skin tones beautifully. I also chose clothing with relatively little color so it wouldn't detract from the color elsewhere in the portrait. Fortunately, my husband Daniel is also an artist and was able to assist our photographer in positioning all the elements, such as the book and clothing, according to my specifications. In my design, the eye level fell just above us, as if the viewer had just entered the room and happened on this intimate moment.

TONING THE DRAWING SURFACE

From all the photos we shot, one particular pose repeatedly caught my attention as I considered my options. I immediately made a detailed drawing in charcoal pencil on a sanded white cloth, which had been dry mounted on to a 40 x 30" (102 x 76cm) Foamcore board. After spraying heavily with fixative and testing its effectiveness, I toned the surface with a transparent mixture of raw sienna and black acrylic thinned with water to create a warm gray ground.

LAYING IN THE DARKS

After allowing the underpainting to dry overnight, I began laying in the darks in the hair using cool umbers and burnt umber. Since the chair provided the dark foil for the skin tones, I laid in the area around our heads with a deep greenish-blue soft pastel. Simultaneously, I began to render the shadows on the faces using a hard pastel in a warm brown color. I also decided to prepare the top of Avignon's dress with a dark gray soft pastel.

Working with a toned background

If you know at the onset of a portrait that you want to maintain a particular color direction, you may want to consider toning the surface before you begin. You can try either a harmonious tone that will establish your color scheme, or a complementary tone, that will add exciting contrast. However, I recommend sticking with a middle value, which will help you establish your overall value range. A water-based medium, such as acrylic, watercolor or gouache, makes a suitable transparent underpainting for pastels, just so long as your surface can withstand wet media. In addition to setting an overall color scheme for your portrait, a toned underpainting can add visual interest in the form of color variations allowed to show through between individual strokes.

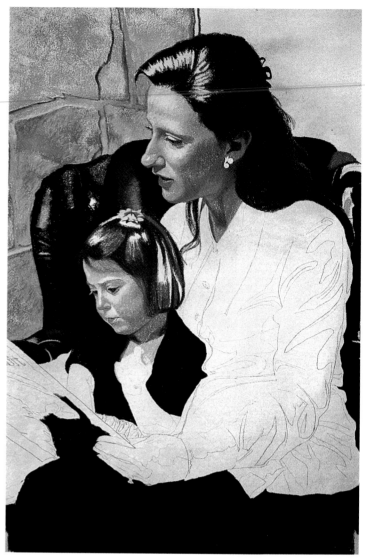

DEVELOPING TWO POINTS OF INTEREST

Next, I quickly laid in the mid-tones and lights across our heads. I used a light touch to keep the tooth of the paper open for later layers of pastel. Since both faces in a double portrait are equally important, I wanted to develop them simultaneously by bringing them to the same degree of finish at each stage. At this point, I was pleased with the progress and felt enthused about furthering the painting.

COMPLEMENTING THE SKIN TONES

As always, my next few steps involved developing the overall pattern of lights and darks, allowing the gray surface to represent the mid-tones within the image. Massing in the correct values helped me visualize the three-dimensional structure of my subject fairly early, as if I were sculpting the image, rather than merely copying the photograph. Specifically, I began to render the stone wall behind us. Notice how the stones are similar in value, although each one contains a myriad of colors with a cool cast, including umbers, grays and ochres, to balance the red tones in our skin.

"Since both faces in a double portrait are equally important, I wanted to develop them simultaneously by bringing them to the same degree of finish at each stage."

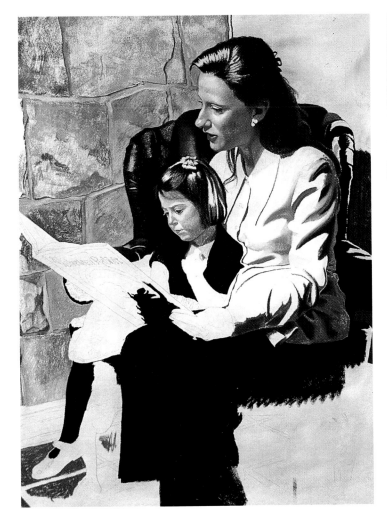

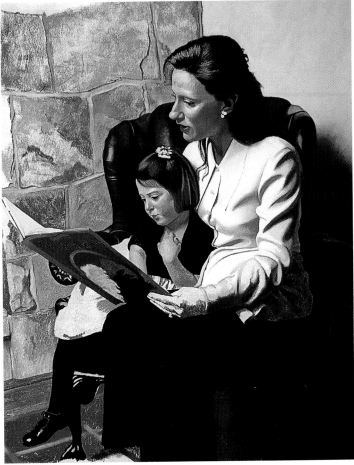

CREATING A PATTERN OF DARKS

Continuing to work outward from the center of attention — the two heads — I prepared the shadows in my blouse and in the chair, placed more dark greens and indigo blues in the chair and built up the dark grays on my trousers and on the wall to the right. I used the red clay tile floor on the lower left to balance the warm skin tones diagonally opposite on the upper right. With these darker values in place, I was ready to strengthen the warm tones of the faces.

BALANCING THE COMPOSITION

Working my way down the composition, I modeled the chair, my blouse and my daughter's leg and foot. I then worked in the warm light tones of her chest, arms and hand, developing them from dark to mid-tone to light. I developed the book and the area beneath the chair using caput mortuum and grayed violet colors. This area was actually lighter in the photo, but I deliberately deepened it to create a strong, wide, dark base at the bottom of the composition, which helps to lead the viewer into the action.

The challenge of your own image

One of the great challenges of painting any portrait is to convey the sitter's personality. This becomes even more intriguing when you attempt to paint yourself. In the process of painting several self-portraits, I was surprised to discover how much analysis it requires to determine how you want to portray yourself. What qualities do you want to bring out to all who see this portrait? Is there some aspect of yourself you'd rather not reveal? There is an irony to being on both sides of the easel. It is a fascinating, rewarding exercise which I encourage every artist to explore. It will certainly help you empathize with any sitter who appears uncomfortable with the portrait painting process.

All the stages of a double portrait at a glance

STAGE 1

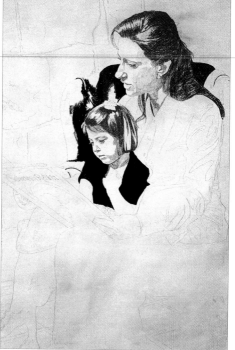

STAGE 2

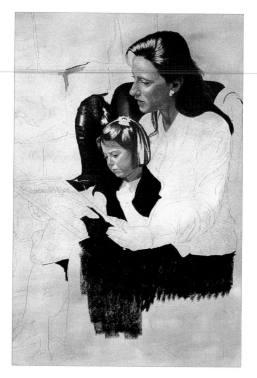

STAGE 3

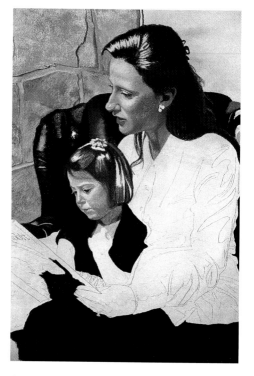

STAGE 4

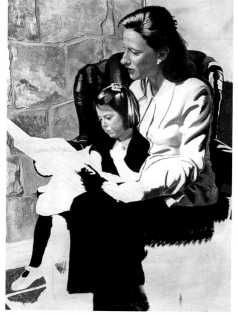

STAGE 5

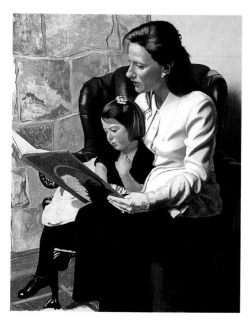

STAGE 6

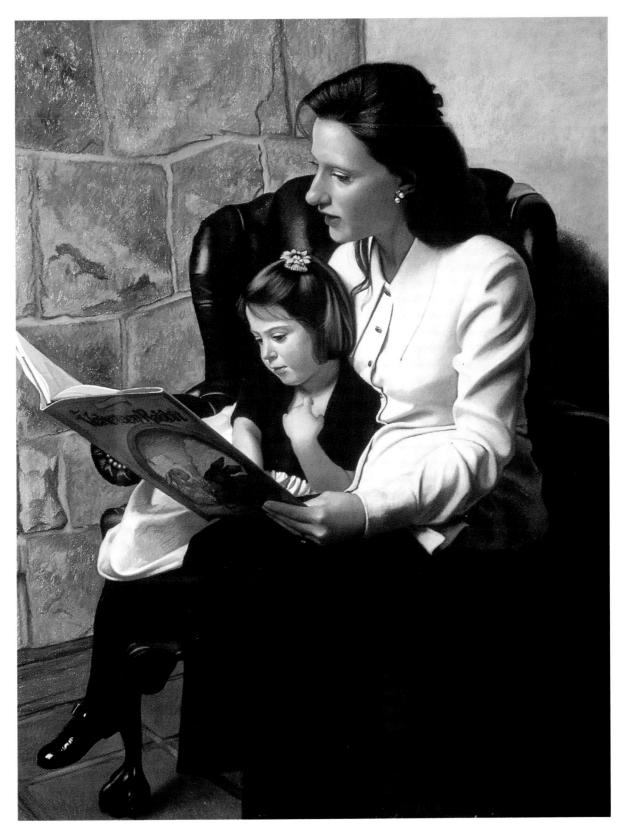

FINISHING FROM LIFE

To complete and refine the image, I worked from life. I positioned my easel so that I could observe this area of the room while I enhanced the details in the chair and fireplace. Then I had my daughter sit for short intervals so I could fine-tune her delicate features and strengthen her color. I modeled the forms in Avignon's dress first and later suggested some of the white-on-white design where it was visible in the mid-tones, which I felt added some delicate interest. I then used ochres, umbers, raw sienna and cadmium red light to render my hand, and viewed myself in a hand mirror to refine the colors in my face. I was quite happy with the strong diagonal design in "Wende and Avignon", 40 x 30" (102 x 76cm), and feel it is an accurate representation of the bond we share as mother and daughter.

Because it's very difficult to get a child to pose for any length of time, I recommend you hone your drawing skills by working with adult models as often as you can.

Taking helpful color notes
*This drawing of "Sara", 11 x 8"
(33 x 20cm) represents the type of
color sketch I like to do at an initial
sitting with a client. Very often
I will not see my model again
until the final sitting, so these
color sketches can provide
additional information beyond
my reference photos.*

Practicing drawing from the live model

My portrait painting method requires an advanced level of expertise in drawing. Although working from photos is convenient, and you have references available whenever you're ready to work, working from life is the only way to learn to draw or paint. Painting from the live model teaches you to be more accurate in terms of proportions and likeness and, at the same time, it frees you from copying something exactly, thereby encouraging you to be more creative with values and colors when you compose your work.

Ideally, your model should maintain their original pose, but they're human, so they move. Tell them gently when they do. While working from a photograph eliminates this problem, it can be difficult to infuse life into the static image found in a photo.

Because it's very difficult to get a child to pose for any length of time, it is best to practice drawing with adult models, as you'll see I have done in most of the examples in this chapter.

Avignon December '98

GETTING A CHILD'S COOPERATION

I created this drawing of my daughter "Avignon", 4 x 6" (11 x 15cm) while she was watching a movie. Distracting them is one way to get a young child to pose for a detailed drawing.

WORKING WITH YOUR MODEL

One year older, and a little more mature, Avignon insisted she could pose without watching a movie. I was delighted with her cooperation on "Avignon", 4 x 6" (11 x 15cm).

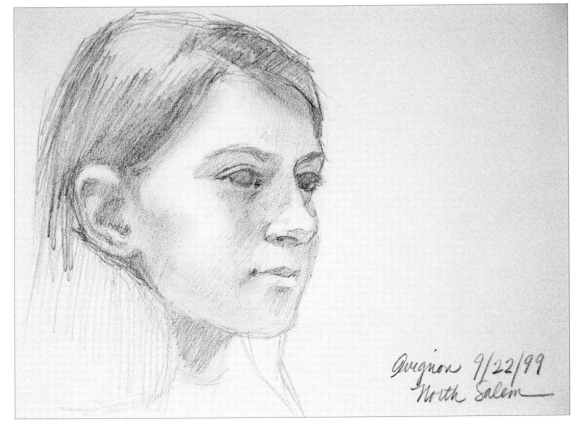

Avignon 9/22/99 North Salem

Demonstration: Measuring to capture an accurate likeness

PHOTO REFERENCE

MEASURING FROM LIFE

When I draw a head from life, I begin with small marks to indicate the size I want the face to be. I make these marks from the top of the forehead to the bottom of the chin. Within that framework, I visually divide the face into equal thirds and indicate, using small dashes, how her face compares to these equal measurements.

BUILDING THE NOSE

In the lower two-thirds of the face I indicate the placement of the eyes, determining the width of the eyelid and opening of the eye. Beneath the nose, in the lower one-third of the face, I indicate the upper and lower lips. I begin to lightly connect the dashes around the nose, paying close attention to the subtle nuances and shifts in the angles of the model's face.

How I measured this model

I began by making two marks, one for the top of the forehead and one for the chin, making sure I positioned the head in a suitable location on the surface. I then stretched my fingers out and used the distance between the tip of my thumb and the tip of my middle finger as a gauge for the average height of an adult face. I never alter these two initial marks, but rather adjust the proportions within this framework when needed.

Next, I divided the head into equal thirds with small marks. The first mark suggests the distance from the top of the forehead to the top of the eyebrow. The second mark indicates the distance from the top of the eyebrow to the bottom of the nose.

Since these proportions are rarely perfectly equidistant, I studied my model closely and adjusted these marks to fit her proportions.

Continuing to look closely at the model, I made small marks to define the length and width of her nose (as if it were the letter "L"). Then I made marks indicate the cast shadow of the nose, the eyebrows, eyes and lids and the upper and lower lips. I then drew the nose, paying close attention to its angles and changes of direction.

To check the accuracy of my angled lines, I held a pencil completely vertical at arm's length in front of me, closing one eye and comparing the angles to this vertical line. These "plumb lines" helped me see the angled lines more easily.

MAINTAINING THE ACCURACY OF
THE DRAWING

*I continue connecting my initial marks
to draw in the eyes and mouth, as well as
the profile of the head. Close observation
to angles and plumb lines helps me place
the components accurately in relation to
the whole image.*

EXPANDING THE DRAWING

*Constantly referring to my model, I use
the width of the visible portion of her face
to determine the overall width of her head.
I then use the position of the eye, nose and
mouth to position the ear and jaw line,
using horizontal plumb lines. Then I begin
to indicate some shadowed areas.*

FINISHING THE DRAWING

*I add more shadows, then I observe each
feature, constantly comparing my drawing
to the model's face. Then the drawing is
sufficiently complete and ready for color.*

*"I strongly advocate anyone to learn to
measure properly — and to keep practicing
until the process becomes second nature."*

TAKING THE OPTION OF
PROCEEDING TO COLOR

*Once I have a fairly accurate, three-dimensional
drawing, I can develop it in color or just as
easily make it a value drawing.*

Demonstration: Painting from life

Randy is a professional artist's model as well as an actor and "live mannequin", so he has the ability to take and maintain thoughtful poses for long periods of time. He is a dream to work with.

We began this portrait in my studio under natural light, but I added the simulated north light spotlight to achieve a more constant effect when the days turned dark and rainy. I composed the portrait with Randy's head slightly to the right and above center, creating an asymmetrical arrangement that offered some visual space on the left for him to "look into".

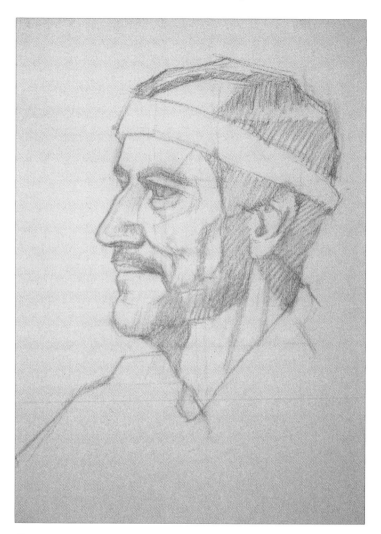

POSITIONING AND MEASURING

Using a warm gray hard pastel sharpened to a point, I began by making small marks to position the head and features as described on the previous page. I made one mark for the top of his face, then spread my fingers wide apart and used the span of the tip of my thumb to my middle finger to position the mark for his chin. I then divided the face into three equal thirds, making marks to indicate the approximate placement of the eyebrows and the bottom of the nose.

Next, looking more closely at the model's face, I began to mark the placement of his features — the length and width of his nose, eyes, eyebrows, mouth, beard and mustache — constantly comparing one with another for accuracy. Once I was satisfied with the position of these marks, I began to connect them until I had an approximate likeness of my model. I then hatched lines of hard pastel to suggest darker values and shadow shapes within the head.

BUILDING DARKS AND MID-TONES

Next, I began placing all of the darks to establish the shadow pattern and give form to the head. After laying in the gray-violet background behind his head, I began to develop the mid-tones of the face. All the time I worked I kept the direction of the light in mind.

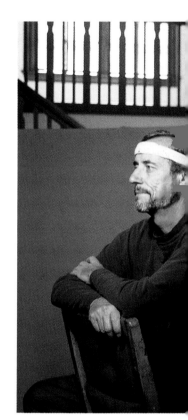

MOVING AROUND THE HEAD

At this stage I wanted to establish the background and clothing. I used some of the violets from Randy's face, as well as deeper blue-violets. I then quickly placed the shadow on his shirt using a cool deep blue-gray. A combination of a lighter cool violet color and some warm tones established the shirt.

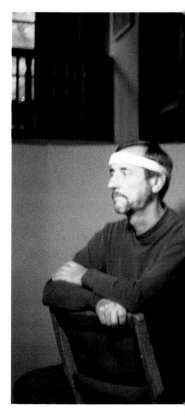

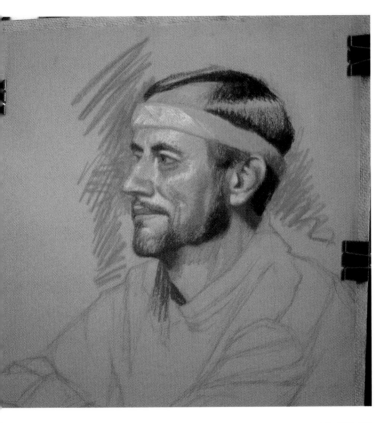

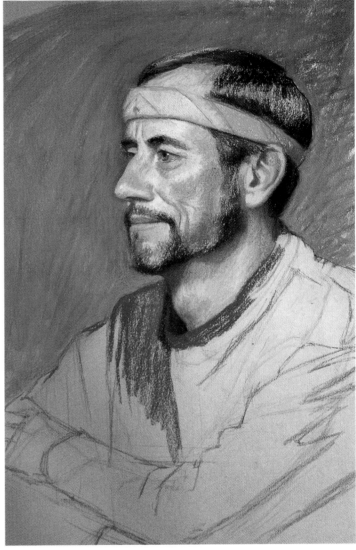

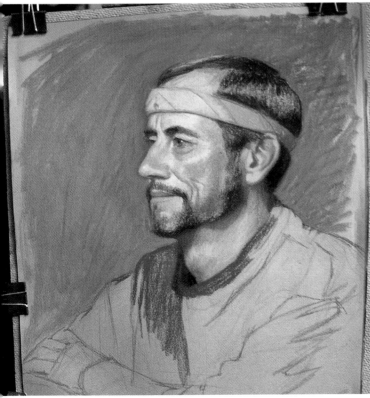

ADJUSTING FOR ACCURACY

During my next sitting with Randy, I inspected my drawing in reverse through a hand mirror and decided to refine the drawing. I widened his nose slightly and narrowed the width of his mouth, altering his beard shadow beneath it.

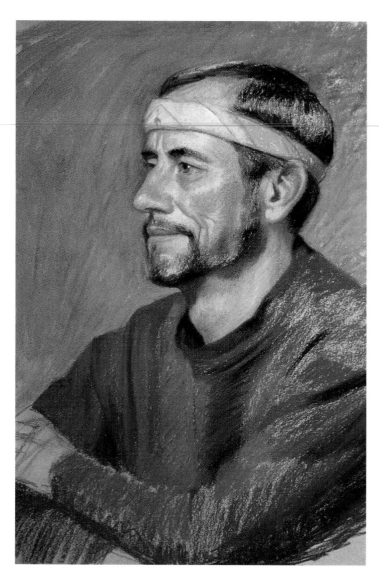

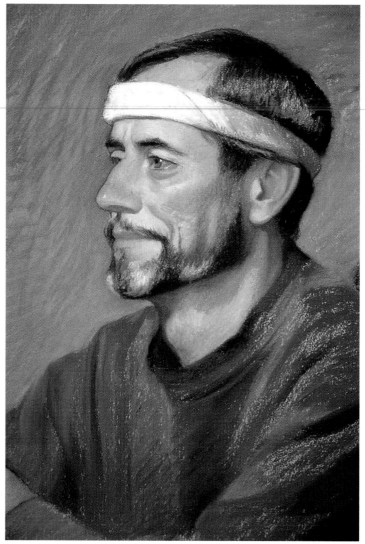

COOLING SOME COLORS

At this point, I found the background too warm, so I adjusted it to a cooler blue-violet. I then refined Randy's clothing, building up additional layers of pastel.

REFINING THE LIGHTS (DETAIL)

I continued to soften edges and build additional layers of pastel on the head, mostly in the lights, pressing a bit more heavily. I used a crosshatched stroke which, in some cases followed the forms, particularly in the head.

"Painting from a live model teaches you to be more accurate in terms of proportions and likeness."

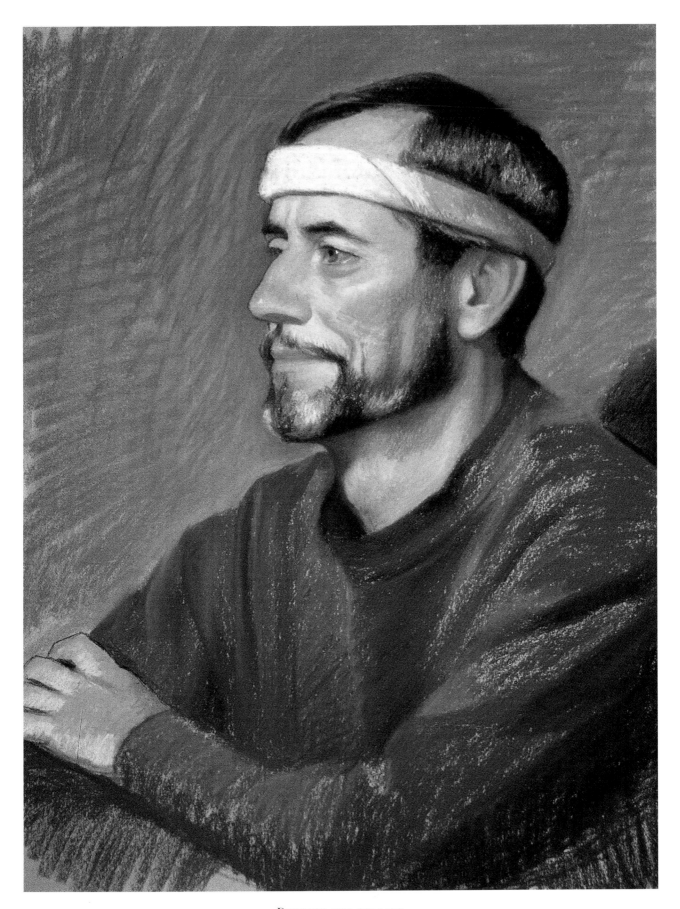

PUSHING AND PULLING

Using the same approach to the background and clothing, I softened edges with more strokes of pastel. In this final stage of "pushing and pulling", I added a few more dark values to complete "Randy", 25 x 19" (64 x 49cm).

TAKING EVERY OPPORTUNITY TO DRAW
*This drawing of my dear friend "June", 4 x 6"
(11 x 15cm) was done while we were traveling in Normandy, France. We wanted to paint outdoors but because the weather was bad, we ended up working in the back of our rental car. I drew June while she painted in watercolor.*

June painting in watercolour 2. Aug. 98 Normandy. France

Vera December 98

GETTING FAMILY MEMBERS TO POSE
During a particularly busy period, my mother came to visit to be with Avignon so my husband and I could work. She reminded me that, as a child, I would frequently draw family members as they watched television. I did find time to draw "My Mother", 4 x 6" (11 x 15cm).

WORKING WITH LIMITED TIME

Randy had come to pose for one of my husband's workshops on portraiture and had a few spare hours to pose for me. He arrived wearing a bright yellow rain slicker and a knitted cap. Although I would have loved to work in full color, I chose to do a value drawing because I had only three hours in which to work. Here's the result, "Randy", 20 x 16" (51 x 41cm).

"Draw from a live model both as an end in itself and as a reference for full-color portraits."

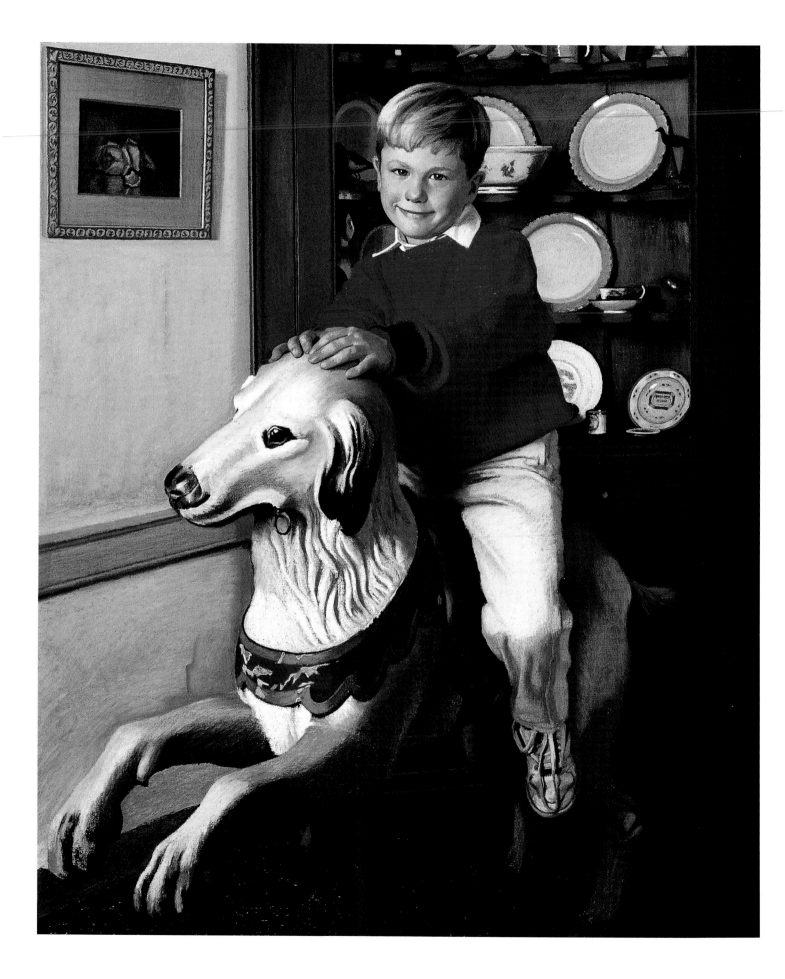

Section Three

Turning your passion into a career

Once you begin painting portraits, the challenge of capturing the model's likeness may become exhilarating enough that you decide you want to pursue portrait painting as a career.

If that is what you want to do, this third section has been designed to help you reach your goals and to get you headed in the right direction before you consider accepting commissions.

In Chapter 12, I explain how to develop a unique personal style and how to lay the groundwork for a career as a professional portrait artist. Then, in Chapter 13, I make suggestions on how to work with a client so you both find the experience satisfying. In the last chapter, I encourage you to study the work of other artists — past and present — for inspiration and solutions as you continue to develop your skills.

This section encapsulates the direction I currently follow to continue building my painting skills and to develop fruitful relationships with prospective clients. It is my sincere wish that you will be able to glean information that will help you achieve a distinctive style and build a foundation for a career as a portrait artist.

MOVING FORWARD WITH STYLE
This portrait of "Greg", 30 x 25" (76 x 64cm) is a companion to "Judd",
on page 8. It typifies not only my current approach and style, but also
the way I like to utilize my creativity to design portraits uniquely suited
to my clients' tastes and preferences.

A key step in the journey toward a career as a portrait artist is to allow your unique style to evolve naturally.

SEIZING THE MOMENT
*"Nick with Swans", 19 x 25"
(49 x 64cm) represents the type
of imagery I enjoy composing
with my camera — a moment
that would be impossible to
achieve by working from life.
The subject matter is almost
incidental because my intention
was to show how the light
affected and defined the shapes.*

Developing your style

s a beginning painter, I obsessed over developing a unique style. Often I tried to emulate other artists' approaches but they really didn't suit my personality. At some point, however, I realized that immersing myself in the act of painting would allow my style to emerge. My work has since become more indicative of who I am, and it continues to evolve as I grow, experiment and synthesize new techniques.

Are you searching for your personal style as well? Although you'll find that it will happen quite naturally as you continue to paint and develop a "pattern" of working that yields consistent results, there are some steps you can take to help the process along. Perhaps my story will provide you with some useful ways to find your style, and to market yourself as a professional portrait artist at the same time.

SPEND PLENTY OF TIME PAINTING

A personal style is usually the result of productive time spent at the easel, perfecting your craft and experimenting with techniques and ideas. All artists need plenty of time in the studio to further their ability to express themselves. I need time to do my commissions, as well as time to paint for myself. Pursuing my own art is essential because it allows me to continue honing my skills, working from live models and experimenting with other subjects and techniques. These stimulating, enriching activities eventually find their way back into my portraiture.

Perhaps you are like me, and cannot devote yourself exclusively to painting. I am a wife, mother and homeowner, as

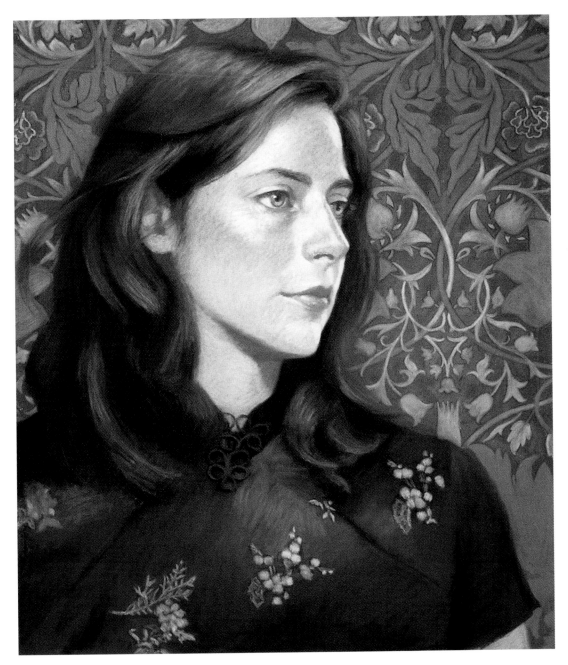

well as an artist and teacher, and I want to perform all of these roles well. I know how hard it is to meet such obligations and demands.

It takes balance to accomplish everything on my agenda. One of the things that helps me is to make a list of priorities. Naturally, my first priority is my family, but my art is what I need to do for myself. Making this kind of list is a great form of discipline. It lets me see what is most important, reveals how I should be spending my time and helps me to say "no" to extraneous activities that could pull me away from my priorities.

I have also learned to engage in activities that serve double duty. For instance, I love to visit museums for inspiration. Fortunately, my husband and daughter enjoy this activity, too. So, a family outing to a museum allows us to be together while simultaneously meeting one of my artistic needs. Likewise, I go for a long walk each morning. Not only does this keep me physically and mentally fit, it gives me time to organize my thoughts, plan my day and often provides inspiration for landscape paintings.

MAKING THE MOST OF YOUR TIME

Besides making a commitment to spending time in the studio, I've had to learn to make the most of my time while I'm there. As I mentioned in Chapter 3, setting up a dedicated studio space and keeping my materials ready is a great first step.

The next hurdle is to find something to paint. For an artist intent on portraiture, this means finding models. I actually found this to be a fairly easy task in the beginning. As the mother of a young child, I came in contact with

PAINTING AT HISTORIC WEIR FARM

SCOUTING LOCATIONS WITH DANIEL GREENE IN NORMANDY, FRANCE

SKETCHING IN NORMANDY, FRANCE

Let me tempt you into the landscape

Although I spend most of my time doing portraits, I enjoy painting many other subjects as well. In fact, there are many benefits to painting something else. Nothing feels more satisfying to me than painting a landscape outdoors on a perfect day after having spent day after day in the studio working from photos. The quick, spontaneous nature of outdoor painting is a perfect complement to the exacting rigors of portraiture.

Should you decide to venture outdoors for a painting experience, I recommend you take:

- A small assortment of landscape colors or a landscape set.
- Full or half French easel.
- Backboard and six large clips.
- Several sheets of paper, board or sanded surfaces in a variety of warm and cool mid-tone colors.
- Charcoal pencils or vine charcoal.
- Medical gloves, hat, umbrella, moist towels, insect repellant and citronella candles.
- Backpack or canvas bag to transport materials.

many other mothers and most of them readily agreed to have their children sit for photographs. Friends, neighbors and relatives are also great portrait sources, since most people are flattered to be asked to pose either for photographs or for live sittings. Working with volunteer models gave me invaluable learning experience in shooting photographs and painting portraits, and even now I still look for models to paint from life.

Another idea is to paint still lifes — which is a great way to practice painting three-dimensional forms.

EXPANDING YOUR HORIZONS

As I previously mentioned, spending time working in the studio is the best way to develop a personal style, but there are a few precursors to this activity that are beneficial:

- Consider formal art education: My training at a commercial art school, Paier College of Art, provided many studio hours working from a model, and gave me a foundation in good draftsmanship and solid academic skills. I then continued my education by taking private instruction with a tutor, who became my mentor and some time later my husband!

- Workshops: I think workshops are a wonderful way to expand anyone's repertoire and break free from a redundant way of working. Not only does this encourage you to try different approaches and materials, you get the chance to share information and exchange ideas with fellow artists. There are many workshops around the world taught by accomplished artists, and taking them has definitely adds to your knowledge of art.

- Outdoor painting: My husband and I often enjoy painting outdoors when traveling, especially when we are accompanied by artist friends. It's a great way to stretch your boundaries, and it helps to improve the ability to paint natural backgrounds in portraits.

- Collecting images: Just seeing great works of art heightens the awareness of ways in which you can direct your efforts. For instance, I especially enjoy visiting galleries and museums, and frequently buy books, prints, postcards or the catalog of a current show. I also keep a reference folder full of magazine pages containing pictures I have responded to in one way or another. Along with my journal, where I write my ideas for future paintings, this collection of images contributes to my creative thought processes and helps formulate and influence the work I create.

- Idea hunting: Over the years, I have trained myself to observe from a picture-making point of view. Wherever I am, I imagine how I might compose the scene into an interesting painting. I've met many other artists who do this as well. This practice will make you more sensitive to your emotional response to the world around you and of the endless potential subjects it holds.

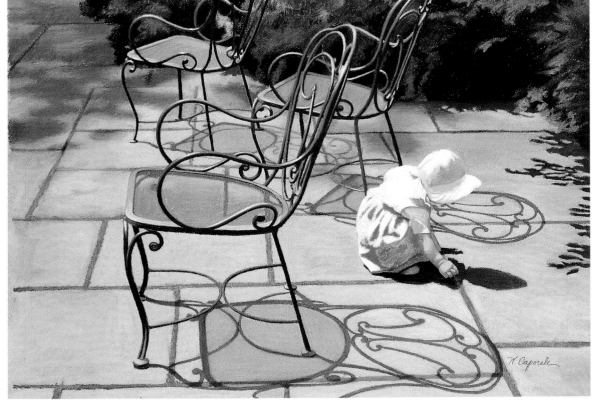

TURNING SHAPES INTO INTERESTING COMPOSITIONS

The figure of Avignon was almost incidental to the overall composition of "Avignon in the Park", 21 x 29" (54 x 74cm).

My focus was obviously the shapes of the chairs and the distorted shadows they cast over the stone terrace. This type of imagery is fun to work with and is a great way to practice composition skills.

EXPLORING VALUE AND COLOR
I was fascinated by the shapes of the horses and the unusual lighting in "Carousel", 30 x 40" (76 x 102cm). *Again my photo references provided the material I needed. In the darkroom, I enjoyed manipulating the black-and-white image to enhance the drama and excitement experienced by the child, and while painting, I had great fun exploring the colors that would best convey the feeling I was after.*

GETTING DOWN TO BUSINESS

Initially, I worked as an illustrator, but over time I found that career to be less than satisfying. Based on my fondness for working with people, I began to move my art career in a different direction by developing my ability in portrait painting. Eventually, although I can't say exactly how long it took, a distinctive look began to emerge in my portraits. I felt it was time to develop a more concrete plan for establishing myself as a professional.

My first step was to investigate the business of portrait painting. I sought out other portrait artists and found some who were willing to share their experiences. I also corresponded with portrait gallery representatives, who were encouraging and informative.

I soon learned there were alternatives to representing myself, such as working through a portrait gallery or broker.

Whichever path I decided to follow, I found it was essential to build a portfolio of 10-12 strong examples of my work. To build up enough confidence to handle commissions on my own, I decided to focus on developing my portfolio by charging a rate that would satisfy my needs and still gain a substantial number of clients.

At the same time, I used the portfolio development period to start spreading the word. For example, each time I completed a portrait I was particularly proud of, I had notecards made and used them at every opportunity. Additionally, to build up my résumé I entered the Pastel Society of America's annual exhibitions and made

a point of entering other competitions. After initially facing some rejection, I was delighted to finally be accepted into exhibitions, which brought exposure for my work, as well as the opportunity to win awards and earn credibility.

At one point, I was asked to teach at the local art center. Although I initially questioned what I had to offer, I found myself gaining a better understanding of the various components of painting — drawing, values, composition, color and edge control — as I explained them to my students. I continue to find this experience rejuvenating.

BUILDING MOMENTUM
Ultimately, building and maintaining my career came down to creating paintings I was proud to show and in looking for every opportunity to show them. I have donated paintings to various organizations (such as my daughter's school and the art center where I teach my weekly classes), I have advertised locally and contributed stories to newspapers and magazines. One of my first forays as a professional happened when I approached an upscale children's clothing store and asked if they would consider displaying my paintings. Eventually, I offered them a 20 per cent commission on whatever sales came through.

That was only the beginning and, happily, I have discovered that maintaining my career's momentum continually challenges my creativity in both art and business. My portrait commissions currently come to me via word-of-mouth and through one of several portrait galleries representing my work.

When to pass up a "good thing"

When you're just starting out, you often feel you should say "yes" to every opportunity that comes along. But this isn't always wise. Whenever you have a decision to make, consider whether the opportunity will get you closer to your goal.

For instance, when I was preparing my first portrait portfolio, someone contacted me about a commission. With great enthusiasm, I scheduled an appointment for him to come to my studio. But when he arrived, he pulled out a snapshot he wanted me to work from. Because I had already decided to work strictly from my own photographs, or those taken at my direction, this arrangement did not fit with the type of work I had envisioned for myself.

Reluctantly, I refused the commission. Had I agreed to do it, the resulting portrait would not have been something I would have been proud to show, and I would have lost valuable time developing my portfolio.

As you pursue your career, plenty of opportunities will come your way. Be selective and choose only those that will move you forward.

WALKING IN THE MASTERS' FOOTSTEPS
Some artist friends and I had agreed to get together to paint at Weir Farm, a local national park owned by J Alden Weir, who frequently painted landscapes and invited other noted artists of his day to join him there. What a thrill it was to walk around the same property and choose a subject, knowing that Sargent, Remington, Hassam and Twachtman had once done the same. At first, the day was overcast so I chose this scene for "Weir Farm", 18 x 24" (46 x 61cm) because of its interesting shapes. Fortunately, in the two later sessions, the raking sunlight added contrast and interesting shadows.

FINDING MEANING

An important component of furthering my career in commissioned portraiture will always be painting work I find meaningful. For example, on a workshop trip to England, I thoroughly enjoyed capturing the fabulous angular head and sharp features of this model in "Homeless", 20 x 16" (51 x 41cm). I used a small portrait set of soft pastels as well as a hard pastel sharpened to a point for the initial drawing.

TRYING A NEW MEDIUM

"Dispersion", 19 x 25" (49 x 64cm) began as an unsuccessful oil painting. Since my objective was to create a strong sense of light and shadow, my husband suggested creating this image in pastel. I worked from a black-and-white photo I had taken, which is the only way I could have attempted an image as complex as this.

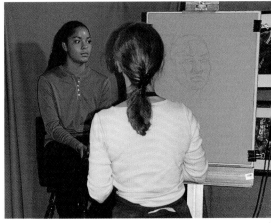

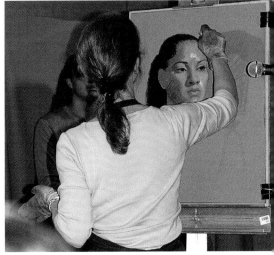

Learning by teaching

Over the years, I have discovered that teaching workshops and giving demonstrations enhances my comprehension of the principles of painting. The more I am asked to explain drawing, values, composition, color, edge control, and the like, the deeper my understanding of them becomes. I thoroughly enjoy being in the company of serious, determined students because I find it rejuvenating and motivating.

From your first encounter with a prospective client to the time you deliver the finished portrait, you can make the experience more enjoyable and rewarding by adopting a professional approach.

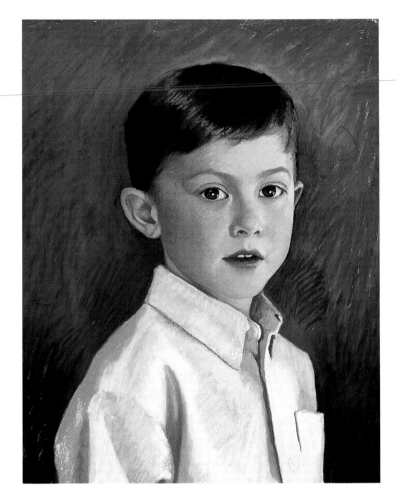

DECIDING WHERE TO MEET
Doing what's best for the clients is usually the guiding force in this decision-making process. For example, I was commissioned to paint "Michael", 17 x 14" (44 x 36cm) by his parents, who live fairly close to me. Although it would have been more convenient for me if the parents had brought Michael to my studio, I chose to photograph him at his home where he would feel more comfortable and therefore be more natural.

Handling business like a professional

You only have yourself to please when you are painting for yourself. It's particularly wonderful because there are no time constraints to consider. The situation changes as soon as you are commissioned to paint for someone else, but the experience can be just as enjoyable. And, being compensated for your efforts is very satisfying!

Communication is the key. Because your clients may or may not have commissioned a portrait before, it's up to you to guide them through the process. If you learn to explain your approach in the beginning they'll know what to expect and will feel satisfied with the end results.

SHOWING THEM EXAMPLES
Whenever I am contacted by prospective clients, I immediately suggest that they take time to review my portfolio. If the clients are local, I invite them to come to my studio where I always have several works in progress. For a client who lives further away, I send approximately twenty 8 x 10" (20 x 25cm) photos of my strongest portraits in a range from simple to elaborate. I also send a complete biography or résumé, which includes exhibitions, prizes, collections and education. With this I include a price list and press clippings or magazine articles. I package these items into an attractive portfolio case that has my name on the front and a handwritten note inside.

I also include a self-addressed mailer so they can easily return the portfolio to me.

Clients need to know that they will get a portrait much like the others I present, which is something I make clear in our initial meeting or follow-up phone call. If they are looking for something entirely different, in another style or medium, I dissuade them from commissioning me. I would much rather lose a commission than be forced to paint something in a different style just to please my clients. This is how I have managed to maintain my individuality as an artist while doing commissioned work.

NEGOTIATING THE DEAL
As discussion continues, it is time to

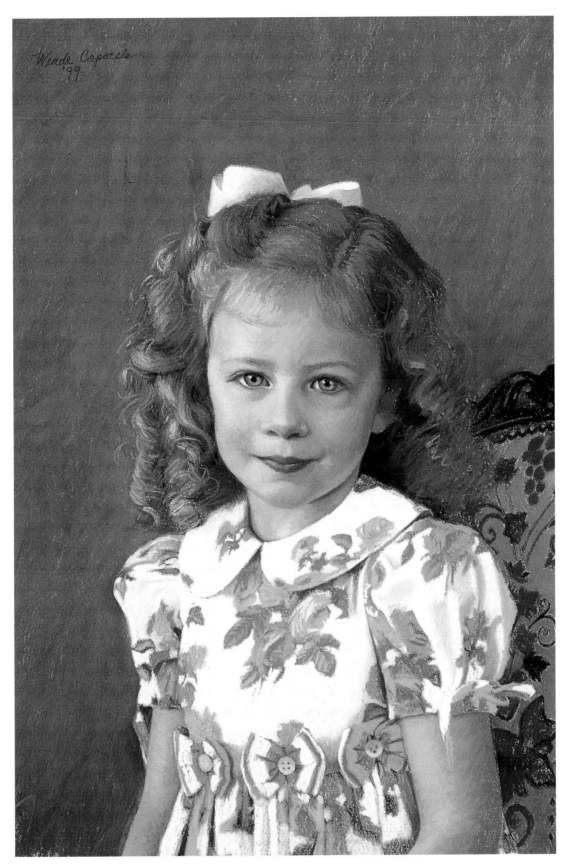

Learning to handle family pressures

Working with a child at home, with other children and parents surrounding me, often requires a great deal of diplomacy. This playful young model, "Olivia", 20 x 16" (51 x 41cm), was adorable, but easily distracted by her older sisters. I tactfully suggested that they entertain themselves quietly in another room. We were able to finish the photo shoot successfully, but I thought an additional sketching period would have been too much for her so I made quick color notes instead.

You should know the realities of this career path before you make a decision. First of all, painting commissioned portraits involves plenty of interaction with other people. As a portrait artist, you will need to feel comfortable "selling yourself" and marketing your skills, negotiating with clients and interacting with your sitters. You must be prepared for the demanding schedule.

Like many beginning artists, you may also have imagined a somewhat luxurious lifestyle working solely in a north light studio from a live model and taking breaks when you are tired. The reality is the hours are very long and you will spend as much time dealing with all the other aspects of running your own business as you will in front of the easel. You must be self-motivated so you can work independently and schedule your time appropriately.

Just as important to your career, however, is skill. You must be devoted to mastering your medium to capture the likeness and personality of your sitters.

Painting professional portraits is an extremely satisfying career, but it is not for everybody. So if you are thinking of becoming a portrait artist, you need to do some soul-searching. You alone can decide if you have the skill, personality and temperament for the job.

address the portrait itself and variables regarding the price. I have developed a fair pricing schedule based on the amount of work involved. Whether I will be painting a child or an adult, I determine my prices based on the following variables:

- View: Rather than thinking about the size of the finished work, I determine the price according to the amount of the figure represented. The options are: head and shoulders only, three-quarter figure ("head and hands") or full length.

- Number of figures: I charge the same price for each figure in a portrait. In other words, the price for a double portrait is twice the price of a single portrait, with no discounts. I do charge less if I am requested to include a pet, but the price varies according to size and complexity.

- Background: I increase the price of the portrait by one-third if the client requests an elaborate background.

- Sales tax: Some states do not collect sales tax, but most do. I live in a state where tax is required, so I add this to my price.

In my experience, deciding on the portrait itself, and therefore the price, can happen in several different ways. Very often, the amount a client is willing to spend will determine the view and background they ultimately choose. I much prefer it the other way around — when the clients decide what they want to see, and then agree to the price.

Then there are times when the clients are not locked into a particular concept and want to see the outcome of the photo session before deciding. When this happens, I make sure to shoot several views against a variety of carefully composed backgrounds to suggest possible directions the portrait might take.

WRITING CONTRACTS AND KEEPING RECORDS

By the end of the negotiations, I should have reached a clear understanding with my client. Just to be sure, I always prepare a contract including the name and address of the person commissioning the portrait; the date; name(s) of the sitter and a brief description of the type of portrait (view, approximate size and whether a detailed background will be included). I also set the due date (I currently have a 10-12 month time-frame). My contract shows the price and the payment schedule. I require a one-third deposit up front.

Another factor that is stated on my price list, and is repeated in the contract, is that travel, accommodation and shipping expenses are not included in the portrait price and will be discussed and billed separately.

There are instances when a client will choose to upgrade to a larger portrait, or request some other change after seeing the photographs from the initial sitting. To prevent any misunderstanding at the conclusion of my efforts, I write up a revised contract showing the new details and price.

The end of the negotiation meeting is also a good time to schedule the sitting and discuss any other concerns. If time or seasons are an issue, I try to schedule the sitting to accommodate the client's needs or preferences. Although the work is a priority for me, many people regard a portrait as a luxury and are willing to wait until a convenient time for all of us.

As I go through this process, I accumulate material for each portrait. Because I always have a number of commissions in various stages of progress, I have found it necessary to organize a file box with hanging folders, one for each of my current clients. In the folders are the signed contract, photo references and negatives, notes taken at the sitting and also any notes from conversations with the client and/or gallery.

In addition, I have a journal in which I keep a detailed record of all of the paintings I have done. The details include the client's name, address, phone number, sitter's name, date, the surface used, amount of time the painting took, some of the materials used (brand names and source), the size and view of the final image, due date, framing information, price, and anything else I feel is pertinent. I often find the need to refer to this information, for example, when a previous client wants to commission a companion portrait.

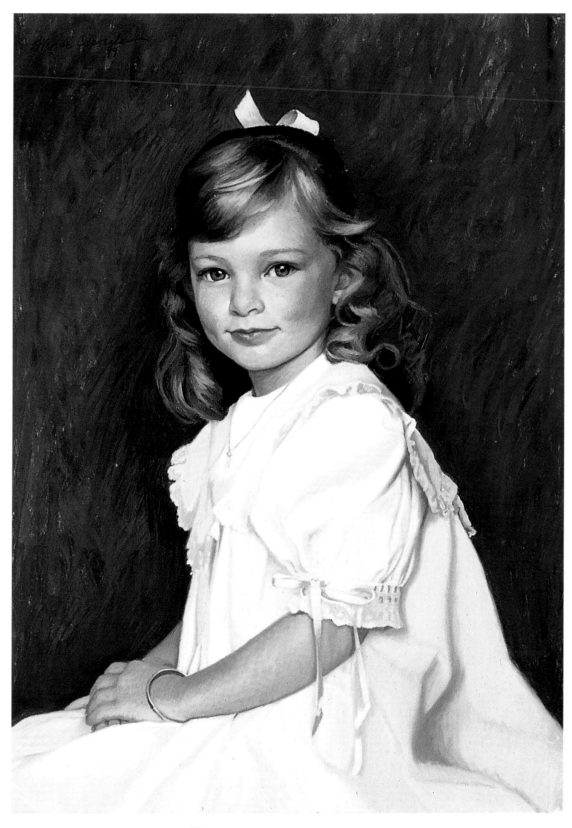

MAKING THE MOST OF REFERENCES

Occasionally, I have the opportunity to meet and work with children who are natural models, such as the child in "Lindsey", 24 x 20" (61 x 51cm). In fact, after my initial photography session, I felt there were many directions in which I could have taken her portrait. Since the family lived several states away, my gallery representative visited the family and assisted them in selecting the reference for their portrait. But in the end, I painted two portraits — this one her parents, and the one on page 33, which was destined to become a sample for my gallery representative to show prospective clients.

Tell them how long it will take

When arranging a sitting with a client, I usually tell them it will take about two hours. However, I also ask them not to schedule anything immediately after the session. Photo shoots and final sittings can run longer than expected, and knowing that the client has somewhere else to go adds an unnecessary element of tension. Fortunately, once I explain the reasons for my request, clients usually happily agree to give me the time and space I need. After all, they want the portrait to be as successful as I do.

GETTING THE CLIENT'S APPROVAL

Before the first sitting, the client's concerns and preferences are discussed. I often hear statements such as, "My child's baby teeth are falling out", or "My child has braces", or "Their coloring is so pretty in the summer". Some of these things, such as braces, are not a real concern unless the child feels self-conscious. But frankly, I have become adept at convincing clients to allow me to suggest poses and expressions that show the sitter's attributes to advantage. Again, this helps clients know what to expect.

The next step is the sitting itself, which I covered in detail in Chapter 2. As soon as I am through photographing my subject, I take the film to a professional photo developer and ask them to print the negatives on contact

sheets or 4 x 6" (10 x 15cm) prints. Later the same day, I am able to pick up the proofs and review them. This is particularly important when I have traveled to do the sitting. If anything is wrong with the photos and they fall short of my expectations, I can schedule a shoot for the next day, before I have to return home, or for a mutually convenient time in the future.

It can be tempting to share all of the photographs with the client right away, but that can overwhelm them. Instead, I prefer to study my options very carefully and narrow the choices down to roughly 10 possibilities. I then have a set of 8 x 10" color prints made from these 10 negatives, as well as a set of photocopies for myself. After numbering each set 1–10, I send the photos to the client, along with any sketches if needed. I indicate which ones I feel will make the strongest portraits, although I encourage them to choose the one they think best captures the sitter's personality. If they have any questions we can discuss the numbered photos over the phone and choose the best reference photo.

I enclose a self-addressed mailer with the photo options so the clients can return the photos to me quickly because some clients can take months before returning the material. A self-addressed mailer seems to facilitate a quicker return of my color references.

SHOWING THE PORTRAIT

When I have developed the portrait as far as I can with the references available, I arrange to deliver it to the client's home and have a final sitting with my subject. When I first began doing portraits that required travel, I did not include this step, but later I felt I was missing a valuable opportunity. First, it allows me to see the client's reaction to the portrait, which has been very favorable most of the time. If the client

feels they want to change something, we can discuss it together and I can make the change if necessary. A personal meeting also creates a good feeling because it lets them know how concerned I am that they are satisfied.

If I am delivering the portrait locally, I create a simple, temporary mat from Foamcore board. I then attach the mat to a backing board, using tape to create a hinge. I then insert the portrait between the mat and backing board and secure it with more tape. This protects the pastel and provides an attractive presentation. I do the same for long-distance portraits, although for extra protection I pack the portrait in a thick cushion of bubble wrap and styrofoam packing peanuts inside a very sturdy carton, preferably a wooden one made by a carpenter. I ship the package, marked "Fragile" in bold red letters, using an overnight service, or I carry it with me and check it at the airport.

When I arrive, the clients are always very anxious to see the portrait, so my first step is to remove it from the carton and present it. More often than not, the client is delighted. I listen carefully to their comments. Sometimes I will hear random, isolated opinions from clients that mean nothing, but if I hear the same criticisms again and again, I pay attention. For instance, occasionally I hear that I go too deep on the shadows or that my color is too strong. I haven't changed my style based on these comments, but I have diversified my portfolio so that clients will know I'm capable of working many different ways. Whether you agree or not, constructive criticism provides you with valid, valuable insights from a marketing standpoint.

Once any amendments or additions are agreed, the next step is to refine the portrait. I set up my French easel, pastels, a chair and a drop cloth for

catching pastel dust. I like to put the model in the same location used for the sitting, but if that's not possible, I put my subject under comparable lighting. I generally spend about 90 minutes per person refining the portrait.

PRESENTING THE BILL AND FRAMING

After completing the portrait, I present the final invoice. Typed on my letterhead, it includes the clients' name and address, sitter's name, type of portrait, total amount with sales tax, deposit received and total due. At the bottom of the invoice, I reiterate that the portrait is absolutely guaranteed. Clients often ask if I want a check then, or if they can send it. Either way is acceptable for me.

Finally, we discuss the frame, which is a subjective decision. I usually recommend framing the portrait as you would an oil painting — without a mat, in a hand-carved frame, in either natural wood or pure gold finish, as opposed to metal. However, framing under glass is essential for protection. Sometimes I accompany the client to the framer, but either way, I give the client a list of instructions on handling and framing pastel paintings (see page 117). I also present a copy of my résumé that they can attach to the back of the frame.

BEING PROFESSIONAL WORKS

I have had nothing but pleasant experiences when painting portraits, and I believe it's because I conduct my business in a fair and professional manner. I explain the procedure to the clients up front. I involve them in the process at each meeting and spell everything out in my contract. Good communication between client and artist makes for a pleasurable encounter for everyone involved.

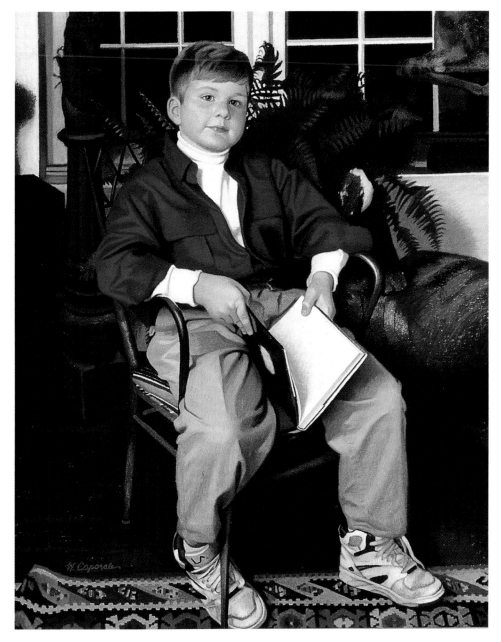

MAKING THE SITTER REAL
Paying attention to the smallest details often gives me the opportunity to make my clients very happy. The woman who commissioned this portrait of "Ben", 30 x 25" (76 x 64cm) was particularly pleased by the way I caught Ben's character, right down to the untied shoelaces!

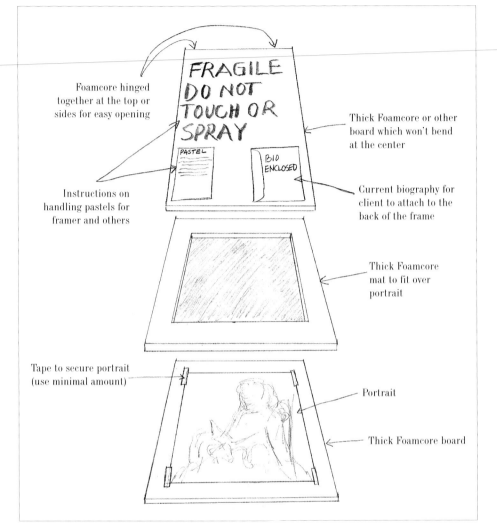

Foamcore hinged together at the top or sides for easy opening

Thick Foamcore or other board which won't bend at the center

Instructions on handling pastels for framer and others

Current biography for client to attach to the back of the frame

Thick Foamcore mat to fit over portrait

Tape to secure portrait (use minimal amount)

Portrait

Thick Foamcore board

FRAGILE DO NOT TOUCH OR SPRAY

PASTEL

BIO ENCLOSED

MY MAIL-OUT PORTFOLIO

If a prospective client lives too far away for me to consult with them personally, I send my portfolio. Presented in a professional way, this portfolio shows the potential client quite a few examples of my work in the form of 10 x 8" (25 x 20cm) photographs. I also include my résumé, price sheet, other relevant materials and a self-addressed mailer so the return of my portfolio is convenient for them.

Getting work from other sources

In addition to the commissions I find and negotiate on my own, I work with several portrait galleries and portrait brokers. Not only do they find prospective clients and brief them on my style, they negotiate the price, arrange the contract and collect the payment for me.

However, because I choose to work both independently and with a gallery, I take steps to maintain a healthy relationship with my representatives. For one thing, I charge the same amount for an independent portrait as the gallery would charge. This way, I never appear to be undercutting the gallery and "luring" business away. Also, if a prospective client contacts me after seeing one of my portraits that was originally commissioned through a gallery, I pay that gallery a commission for their contribution to this arrangement. Practicing business fairly and ethically guarantees my success with the galleries.

CRATING THE PORTRAIT FOR SHIPPING

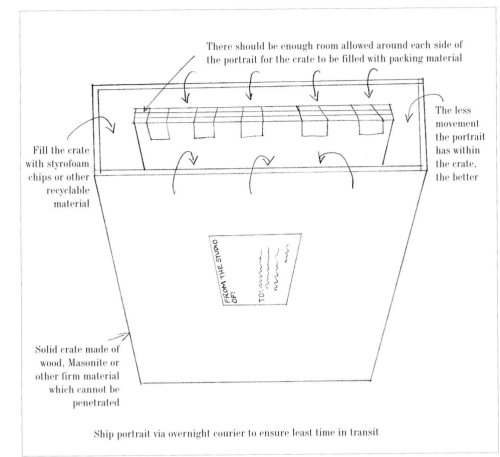

There should be enough room allowed around each side of the portrait for the crate to be filled with packing material

Fill the crate with styrofoam chips or other recyclable material

The less movement the portrait has within the crate, the better

FROM THE STUDIO OF:
TO:

Solid crate made of wood, Masonite or other firm material which cannot be penetrated

Ship portrait via overnight courier to ensure least time in transit

"I have had nothing but pleasant experiences when painting portraits, and I believe it's because I conduct my business in a fair and professional manner."

Instructions for handling and framing pastel paintings

If handled properly, a pastel painting will last for many years and will retain its brilliant color.

- Pastels are pure pigments and should not be touched or sprayed with fixative before framing. Touching or spraying the surface will damage the portrait.

- Use only archival, acid-free materials for the backing board, matboards and for anything else that comes into contact with the painting.

- Frame your painting under glass to protect its surface, but do not let the painting come into direct contact with the glass. Use a $\frac{1}{4}$" thick, 100 per cent rag, acid-free matboard or a $\frac{1}{4}$" wood fillet to keep the glass away from the surface.

- I recommend choosing the type of glass that allows the painting to be seen without unsightly glare and that protects it from UV rays. Be aware, however, that some brands of glass have a slight "sheen", which affects the brilliance of the color.

- I use only permanent color pigments that will not fade. However, I still recommend keeping your painting out of the damaging rays of direct sunlight.

- Do not hang your painting in a very moist environment, which can cause mold to develop.

You can learn a lot from studying the work of past and present day masters.

BURTON SILVERMAN
This painting, "Reverie", 22 x 14" (56 x 36cm), reveals why Burt Silverman is often compared to Degas. His use of compositional juxtapositions of shape, his exquisite draftsmanship and his sensitivity to the human condition, are what makes his work mesmerizing. The balance of simply executed passages with more fully realized areas is only accomplished with great skill.

Finding inspiration in the work of other artists

aintaining your growth as an artist requires ongoing effort. Occasionally you may reach a plateau that will prompt you to question where you are going and how you can stretch yourself to improve your work. When I'm in this situation, I find it very helpful to break out of my routine and do something unusual. You may consider taking a workshop, switching to a different medium or exploring alternative subject matter — anything to deviate from your customary habits. Force yourself to look at the world with fresh eyes.

LEARNING FROM THE MASTERS
Taking the opportunity to look at great works of art in museums is one of the most enjoyable ways I know of to find inspiration. I particularly enjoy immersing myself in the history of pastel art and exploring the work of the great masters of this medium.

Originally, pastel was used primarily as a sketching tool or to embellish drawings. At first, it was only available in three colors — red, black and white — although a larger range of colors became available in the late 15th century. By the late 1600s, artists began to recognize the diverse capabilities of the medium. Two of the

Harvey often exhibits at the Pastel Society of America's annual exhibition in New York. His work always possesses a strong, active composition, and there is a controlled verve in his modeling of the figure. I enjoy the feeling of happening upon a moment in which the subject is completely caught up in an activity, oblivious to the artist's attention, as in "Morning Light". 16½ x 27" (42 x 69cm). Harvey's work has a natural quality that I always find thought-provoking.

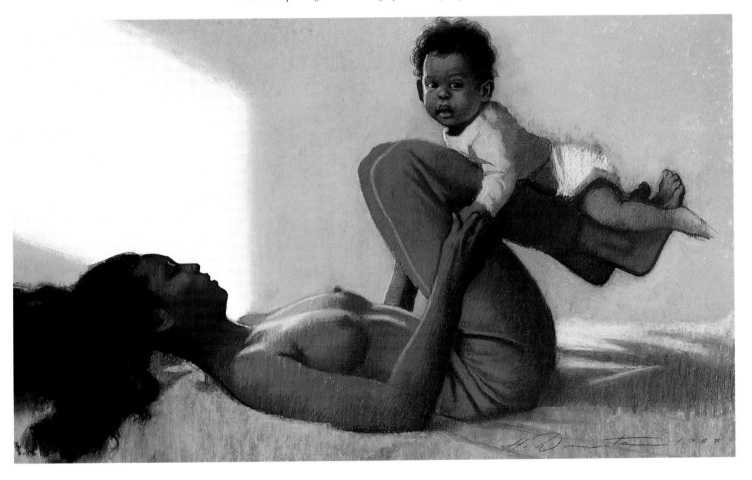

most obvious advantages were the speed with which the artist could use pastels to capture a fleeting image and the rich textural effects that could be obtained.

One particular artist is now credited with popularizing the medium and encouraging its use in Europe in the early 18th century. Rosalba Carriera (1675-1757), who was born in Venice, began to use the medium as an end in itself in fully realized pastel portraits.

Not only was she highly regarded in Italy, and elected to membership in notable academies, she was also invited to France, where she was commissioned to paint the young King Louis XV, which resulted in even greater recognition.

Rosalba's work had a significant effect on several other artists who were also receiving recognition for their pastel work at the time, including Maurice-Quentin de La Tour (1704-1788),

Jean-Étienne Liotard (1702-1789), Élisabeth Vigée-LeBrun (1755-1842), and Jean-Baptiste-Siméon Chardin (1699-1779), who became an acknowledged master of pastel late in his career. Jean-Baptiste Perronneau (1715-1783), Chardin's primary rival, is said to have influenced Degas through his distinctive technique of building pastel in crosshatched networks.

The Barbizon School, particularly

Jean-François Millet, is credited with the revival of pastels in the 1850s, although it was Edgar Degas (1834-1917) who in the late 1800s used the medium's full versatility, spontaneity and vigor. His unique vision and methods put him at the forefront of the Impressionist Movement and confirmed his enormous contribution to the history of art. A fellow Impressionist who was singled out by Degas and asked to join their exhibitions was Mary Cassatt (1844-1926). Despite being a woman and a foreigner, Mary became widely known and was greatly respected throughout Paris for her sumptuous pastel paintings of women and children.

Another expatriate American artist, James Abbott McNeill Whistler (1834-1903), used pastels to create elegantly understated figure paintings with delicate, abstract hints of color. The medium was perfect for the brevity he wanted, and his pastel work exerted a greater influence on his American contemporaries than any other artist.

During the 19th century, many American artists traveled abroad to see and try the eclectic range of styles. In particular, they were challenged to follow their European counterparts outdoors, and this new approach broadened their repertoire of media to include both pastel and watercolor. They found pastel to be spontaneous with a broad range of color and brilliance without the limitations of oils, such its slow drying time and the vast array of materials required.

Spurred on by a growing interest in the "avant garde" movement, publications and societies were established to further educate, promote and sell works of art in less traditional media to American buyers. The Society of Painters in Pastel was founded by a group of American artists in 1882 in New York City. This encouraged the formation of other

EVERETT RAYMOND KINSTLER
If there could be a painting equivalent to the sculptures of Rodin, it would have to be the work of Everett Raymond Kinstler. His bold, assured approach is exciting, and he uses pastel like a sculptor, carving and modeling the forms, as evident in "Lea", 24 x 20" (61 x 51cm).

societies in Paris and London. Works exhibited by these societies revealed diverse stylistic trends, from sketchy experimental drawings to ambitious compositions that rivaled oils in size and complexity.

Although some of these organizations have since ceased to exist, the pastel medium has continued to enjoy popularity throughout the 20th century. New pastel societies have taken their place, exhibitions have continued to meet with public acclaim and many of

the century's leading artists, including Georgia O'Keeffe, John Marin and Joseph Stella, embraced the medium.

As part of my growth process, I continue to seek opportunities to study original work by master pastelists, both past and present. I feel fortunate to share with you here a few examples of the representational work of some of the most significant contemporary American practitioners in pastel. Several of the artists featured have taught or currently teach at either the Art Students League

or the National Academy of Art.

Studying the works of others has inspired me to try a variety of special techniques and has helped me to refine my style. For instance, my use of a toned surface, which makes it far easier to establish an accurate range of values, evolved after studying with my husband, Daniel Greene. Through Degas and Cassatt, I discovered how to build layer upon layer of vibrant, scintillating color and a myriad of textures created by weaving or crosshatching the strokes.

MARY BETH McKENZIE

Mary Beth has developed a unique approach to pastels that results in a scintillating surface effect. She often starts with a white board and creates an underpainting in gouache. Not only does this enable her to set up her value patterns, it also allows her to establish color relationships and set a mood. In some cases, as in "Nude Study", 30 x 40" (76 x 102cm), she adds pastel only to those areas she feels need it, which generates a wonderful interaction between the two textures.

"Studying the works of others, has inspired me to try a variety of special techniques, and has helped me to refine my style."

And by borrowing another technique favored by these same artists, I learned to develop some areas of my paintings in a fully rendered fashion while leaving other areas more broadly prepared and less defined, a technique that suggests the immediacy of the moment.

MAKING CONTACT

If you'd like to expand your horizons by seeing the works of your fellow artists, you may want to consider joining your local pastel society. You may also want to attend the annual exhibition of the Pastel Society of America, held in New York City each September at the historic National Arts Club. Attending exhibitions by pastel societies is a wonderful opportunity to observe the myriad of ways in which pastel can be handled.

DANIEL E GREENE

Since my days as a student at Paier College, I have always admired how Daniel E Greene's work possesses a subtle, sensitive quality balanced by a dynamic use of the medium. In "Antique Rug", 24 x 36" (61 x 92cm), for example, I'm drawn to the striking contrast between the texture of the rug and the figure, as well as the rich tones throughout. I am deeply indebted to Daniel, who is now my husband, for all that I have learned from him.

Look up these Masters

While nothing can compare to seeing great pastel paintings in person, you can frequently find notable paintings in art history books. Some artists to research are:

Rosalba Carriera	James Abbott McNeill Whistler
Antoine Watteau	Dante Gabriel Rosetti
François Boucher	Cecilia Beaux
Maurice Quentin de La Tour	William Merritt Chase
Jean-Baptiste Perronneau	John Henry Twachtman
Jean-Étienne Liotard	Daniel Chester French
Jean-Baptiste-Siméon Chardin	Edwin Austin Abbey
Edgar Degas	Bryson Buroughs
Mary Cassatt	James Wells Champney
Giuseppe de Nittis	

"KRISTEN", 20 x 16" (51 x 41 cm)

Occasionally, I am asked to paint a portrait of a very young child like this one. More often,
clients choose to wait until a child is between three and four because their teeth are in place
and they have a more individual look about them.
For this painting of Kristen, I chose to work just under life size and include her hands. These
are personal preferences but because the child is so small, the hands add a bit of character.

Section Four

Gallery of portraits

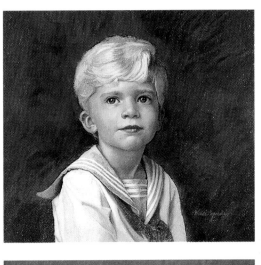

"JOHN", 20 x 16" (51 x 41CM)

The reference photos for John's portrait were taken during the winter in the northeast part of the United States. I mention this because working with natural north light and its changing effects can be particularly difficult when the days are short and there is very little sunlight. These days, I tend to schedule my sittings during the spring, summer and fall, when the weather is much more conducive to travel and there are fewer obstacles.

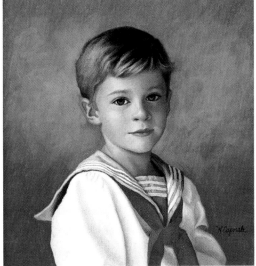

"THATCHER", 15 x 14" (38 x 36CM)

This portrait was one of several which had been commissioned by Thatcher's grandmother. When I first visited with her, she had portraits of her husband, his father, and his grandfather and her two sons in pastel displayed in her living room. She explained that she planned to maintain the tradition of having portraits done of all the men in her family at around six years old wearing sailor shirts, since this evidenced their continued passion for sailing. Because the portraits varied in size, I measured all of them and compared the various sizes of the heads. Based on this information, I chose to work under life size for her four grandsons' portraits. The sailor shirt she provided happened to fit two of her grandsons but for the other two, I had to select a similar color shirt for the boys to pose in and was able to use the actual shirt to work from. When doing this, I had to be certain that the shirt had the same type of lighting as was used for the children and I positioned it on a mannequin to obtain the proper folds.

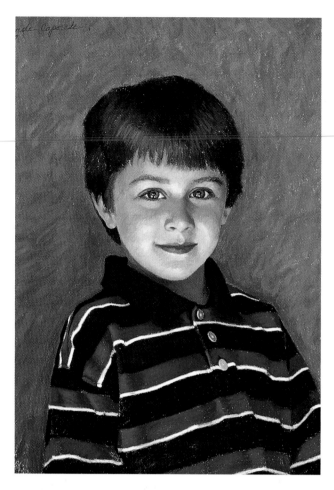

"JAKE", 20 x 16" (51 x 41CM)

The reference photos for this portrait were taken in Jake's home using available north light from a group of French doors. I was delighted by the strong reflected light, a result of a glossy marble floor in the room where we were working. Because I found the effect on his face so pleasing, I used this reference for the portrait. Often when I work away from my studio with its controlled north light arrangement, I have to create a workable setting in my client's home which naturally leads to some variation in the lighting arrangement. I find these instances exciting and challenging but, because I do not like surprises when working with clients, I make sure I also pose the sitter in a traditional north light, with enough shadow to show the structure of the head.

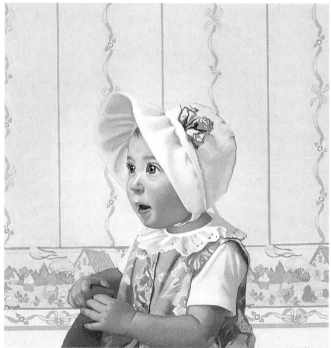

"AVIGNON", 14 x 14" (36 x 36CM)

This portrait of my daughter was done when she was not quite a year old. As I have mentioned, most clients prefer to wait until their children are a little older, but since I had lots of time at home with her, I thought it would be interesting to "document" how she was at such a young age.

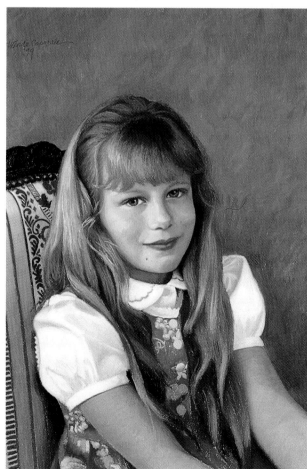

"KATHERINE", 20 x 16" (51 x 41CM)

Although I seldom include any background for a head and shoulder portrait, sometimes a particular element lends itself to the occasion — in this case it was the chair with its ornate design. In most cases additional props can distract the viewer from the main subject. Here I thought the chair added width at the base, and would help to lead the eye towards the subject.

"LINDSEY", 18 x 14" (46 x 36cm)

When Lindsey posed for her portrait, she had a number of dresses from which to choose. This is always a good idea since the choice of clothing adds a distinctive note to the portrait; suggesting either a formal or a more relaxed attitude, as well as conveying the personality of the sitter. In this case, although the design on the dress was quite prominent, I felt it worked beautifully with Lindsey's complexion.

About the artist

Wende Caporale is a Master Pastellist with the Pastel Society of America. She has received many awards from the PSA as well as from the Connecticut, Kansas and Maryland Pastel Societies.

Wende began her art career as an illustrator working for clients including Reader's Digest, Saatchi & Saatchi, Duracell, Xerox, Pepsi and Macmillan Publishing. The Society of Illustrators selected her work from its 27th Annual Exhibition to be part of its traveling show, which was held at eight universities across the US.

Coinciding with the birth of her daughter in 1991, Wende shifted the focus of her work towards portraiture, primarily in pastel.

Wende's work has been exhibited at the Hammond Museum in North Salem; the Society of Illustrators Museum of American Illustration in New York; the Hermitage Museum in Norfolk, Virginia and the Monmouth Museum in Lincroft, New Jersey. She has also been included in numerous group exhibitions with the Pastel Society of America and Allied Artists, both held at the National Arts Club in New York. She has also exhibited at Grand Central Galleries and Master Eagle Gallery, New York City; The Greenwich Workshop Galleries, Southport, Connecticut; the Pastel Society of America in Taichung, Taiwan; and jointly with her husband, Daniel Greene, at The Northern Westchester Center for the Arts in Mt. Kisco, New York.

Dedicated to educating her fellow artists, Wende has contributed to several art instruction books and magazines, including a full-length feature in the inaugural issue of *Pastel Artist International*. She is also a popular instructor of pastel at the Northern Westchester Center for the Arts in Mt. Kisco, New York.

She is often invited to lecture and demonstrate for organizations such as the Pastel Society of America, the Portrait Society of America, the International Association of Pastel Societies and the American Society of Portrait Artists.

She holds a BFA from Paier College of Art in Hamden, Connecticut, and has continued her studies at the New York Academy, the National Academy, the Art Students League and in private workshops. She and her husband live in North Salem, New York, with their daughter Avignon and their dogs, Velvet and Ranger.